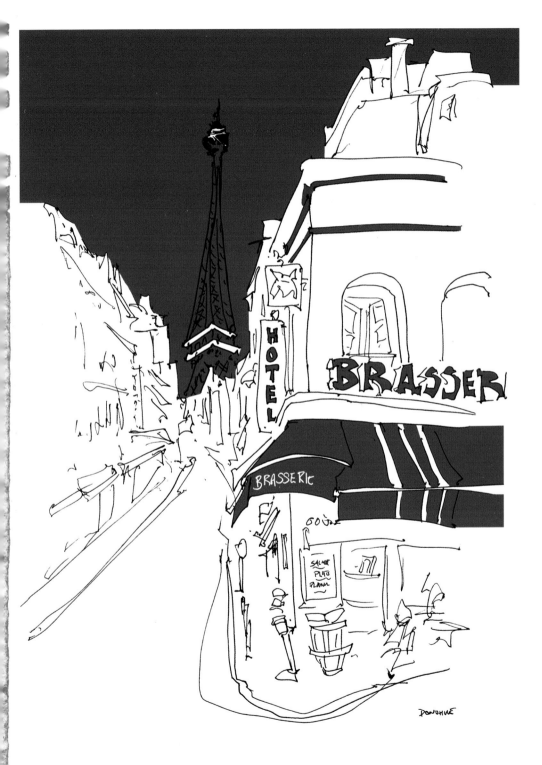

To Sarah, Aurora, and Isis

MON SOLEIL, MON AIR, ET MON EAU

A TABLE IN PARIS

The Cafés, Bistros, and Brasseries

of the World's Most Romantic City

John Donohue

Abrams Image | New York

CONTENTS

*It takes a special magic to run a successful restaurant. Under the best of circumstances that spell only lasts so long. Given the changes in the world since my visit in 2019, a few of these places may have closed, but they will forever remain enchanting.

INTRODUCTION

Nowadays, when dining out in a major metropolitan area, it's easy to find everything from Albanian to Zambian cuisine, but for generations, eating in a restaurant meant having French food. This is because the concept of paying to enjoy a prepared meal at a table while being served arose in eighteenth-century Paris, following the upheaval of the French Revolution. The ensuing decades saw the introduction of bistros, bouillons, and brasseries, and by 1903, Auguste Escoffier had put it all into writing. His *Le Guide Culinaire* has been a standard-bearer on how to run a kitchen ever since. The word *restaurant* itself even comes from the French *restaurer*, which means "to restore." I love to eat, and drawing restores my sense of calm—the act of putting pen to paper brings me the same sense of well-being as a good meal brings most everyone else. For years now, I have made it my project to sketch restaurants in my own home city of New York and beyond. It was only natural that I should head to Paris, long the culinary capital of the world.

I took two trips there in the summer of 2019, walking about the city and drawing, as well as cooling out during 107-degree days at the Monoprix (a sort of French Target and rare place with air-conditioning) and weaving between the lingering Yellow Vest protests. Looking back now, I count myself lucky that I arrived before the coronavirus precipitated a public-health crisis and caused many restaurants around the world to close their doors. When I was there, the dining scene was in full, glorious bloom.

I work in ink, from life, without corrections (later adding the color at home). It takes me about twenty minutes to do a drawing, so in a way, my drawings represent a brief moment of lost time. My spare and loose style captures something essential and ineffable about a place, letting the viewer's mind fill in the details from a memorable trip or, perhaps, whetting an appetite for a future feast.

When I planned my Paris sojourns, I reached out to people who know and love the city, including chefs, restaurant owners, food writers, journalists who live there, and world travelers. While many excellent guides to Paris exist, I have found that personal recommendations can unearth unexpected jewels. One of the best meals I ate on my trip was at a small place, Quinsou, that has yet to really register on travel websites or make its way into guidebooks. I learned about it from the waitstaff at two well-respected and delicious restaurants—Clown Bar and Verjus.

When dining in Paris, there are a few things that are helpful to know:

Reservations are a must. I learned this the hard way by wandering in solo to many an empty restaurant without prior arrangement and being told that, despite the vacant tables, they were all booked.

Dining hours are generally noon to 2 P.M. for lunch and 8 to 10 for dinner. If you want to save money but eat very well, make lunch your big meal out. The most expensive places are comparable bargains this way.

Your presentation matters. This is the way it is in Paris. Dress well to get treated well.

Language: For all practical purposes, it is quite possible to get by without speaking any French, but as with the point above, if you can make a little effort, it will go a long way.

> *Entrées* are appetizers and *plats* are main courses. *Dessert* is dessert, and not to be missed.

Finally, these are the different types of restaurants:

Cafés predate the Revolution and proper restaurants, but they are still a great place to spend a few hours (or a few decades).

Bistros, small casual places typically run by a married couple, are the heart of French dining.

Bouillons are great big halls that were developed in the second half of the nineteenth century to serve meals of the working class (a bouillon is broth) at low prices. Many still exist, and they are beautiful examples of art nouveau style.

Brasseries, which tend to be larger than bistros and have more elaborate menus (the word *brasserie* translates as brewery) and longer hours, were introduced by Alsatian refugees at the dawn of the Belle Époque.

Restaurants are more formal, often with tasting menus and, depending on where you go, stools for handbags—and very high prices.

Caves à Manger are a new phenomenon—wine shops where food is also served. They tend to have longer hours and small plates and are a lot of fun before or after a meal (or in their own right).

The restaurants in this book are organized by neighborhoods and nearby landmarks, from the Champs-Élysées and Arc du Triomphe to the Canal Saint-Martin and les Buttes-Chaumont. Wherever you see a longer list of recommendations, the places present in the neighborhood at hand are marked with a star. There's a map and an index at the back if you are looking for a specific place, and sprinkled throughout are additional ideas about places to go and things to do from many of the experts and locals I consulted. I hope these pages and my drawings inspire a journey to Paris, whether real or imagined, and sooner rather than later.

1

Around Champs-Élysées and L'Arc du Triomphe

Alan GEAAM Restaurant

19 RUE LAURISTON, 16TH ARR.

In the nineties, Geaam, a self-taught chef who was born in Liberia to Lebanese parents, arrived in Paris penniless and homeless. He has since gone from working as a dishwasher to picking up a Michelin star at his self-named restaurant.

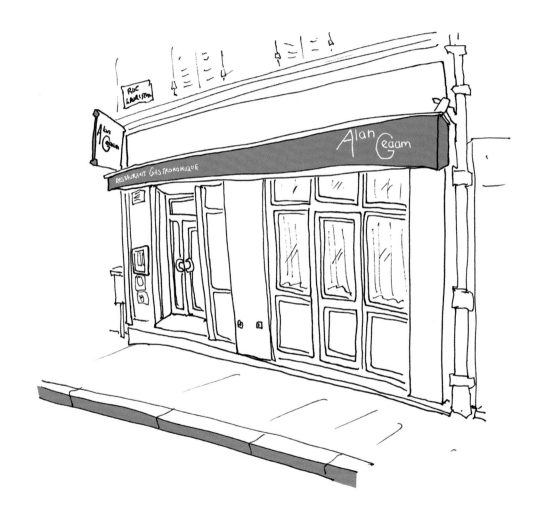

11

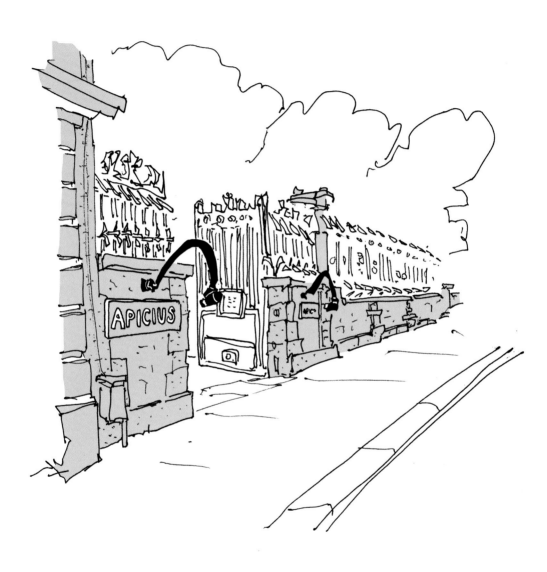

Apicius

20 RUE D'ARTOIS, 8TH ARR.

For my birthday a few years ago, I wanted to live a culinary experience completely out of the ordinary, so I booked a table at Apicius, located in the 8th arrondissement of Paris in the heart of the Golden Triangle. My partner and I entered the restaurant, which is in a Parisian mansion surrounded by a courtyard, and we completely detached from the hustle and bustle of the capital. The food was as modern and delicious as can be imagined, and the wine list is just as impressive as the building itself. It brings together some of the most prestigious French wine estates spread over multiple great vintages. As I am a sommelier, the one at Apicius wanted to share with us some particularly delicious spirits, in addition to the wine we had taken for the dishes as well as Port, which delightfully accompanied our chocolate dessert. A visit to the cellar was gladly offered to us by the sommelier, and the illusion of suspended time in that Parisian mansion remains with me to this day.

—VALENTIN GRINON,
a sommelier from Avignon who worked with vineyards in Châteauneuf-du-Pape and Saint-Émilion before coming to Paris, where he selects wine for private events through his company, Liber Vinum.

14

The dining rooms at Apicius are located inside a
limestone mansion beyond a moat of gardens.

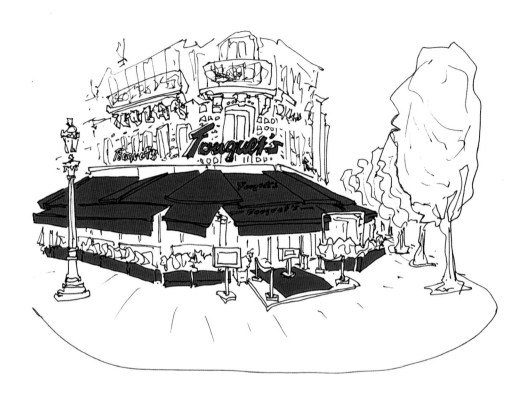

Le Fouquet's

99 AVENUE DES CHAMPS-ÉLYSÉES, 8TH ARR.

That the Yellow Vest protesters torched this commanding place on the Champs-Élysées in 2019 is a testament to its status. (Among its many noted patrons over the years was former French president, Nicolas Sarkozy, who celebrated his election-night victory here in 2007.) It was quickly rebuilt, but it's worth noting that many say Sarkozy's big night out cost him reelection five years later.

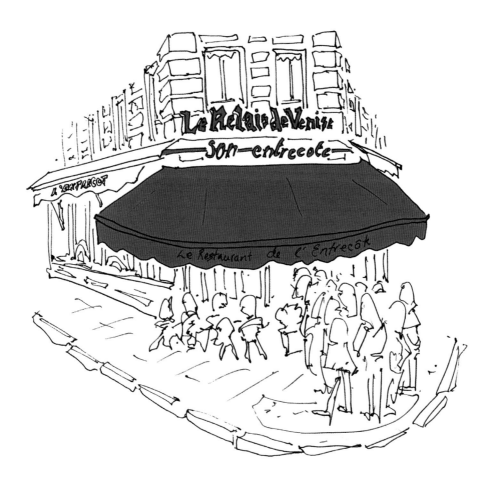

Le Relais de Venise L'Entrecôte

271 BOULEVARD PEREIRE, 17TH ARR.

The original place for steak frites, special sauce, and nothing else, not even a menu (and don't even think of asking for ketchup).

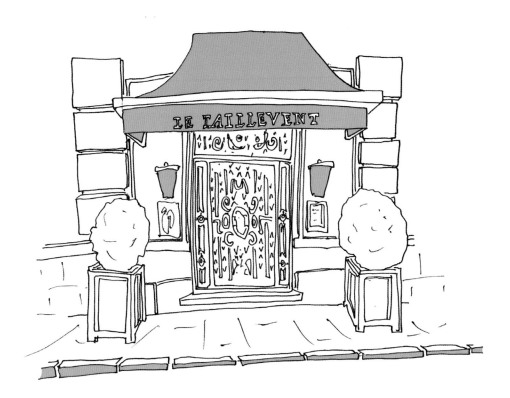

Le Taillevent

15 RUE LAMENNAIS, 8TH ARR.

Named for the alias of the fourteenth-century cook Guillaume Tirel, who wrote the first French-language cookbook, *Viandier*, this institution of haute cuisine opened in 1946.

Pierre Gagnaire

6 RUE BALZAC, 8TH ARR.

Patricia Wells, a big fan of the idiosyncratic mastermind whose name is on this three-star institution, once wrote of dining here, "Don't forget to fasten your seat belt. It may well be a bumpy and memorable ride."

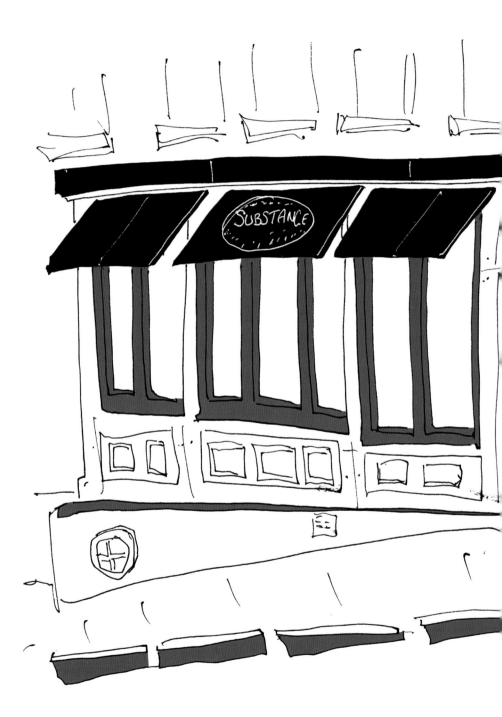

Restaurant Substance

18 RUE DE CHAILLOT, 16TH ARR.

The cult champagne producer Anselme
Selosse curated the list at this white-hot
bistro (the restaurant is named for his
flagship offering), so even if the young chef
Matthias Marc's cooking weren't so electri-
fying, it would be worth a visit. But it is, so
don't think twice.

Shabour

19 RUE SAINT-SAUVEUR, 2ND ARR.

The new place of the Balagan team on the rue Saint-Sauveur, which opened in the fall of 2019. Amazing food, great atmosphere in an open kitchen.

★ Le Boeuf sur le Toit

34 RUE DU COLISÉE, 8TH ARR.

A very famous brasserie in Paris, now on the rue du Colisée. Created in 1922, it was where all musicians, *artistes*, and writers spent their evenings. Jean Cocteau used to own the place.

Café Mar'co

4 RUE DE LA SOURDIÈRE, 1ST ARR.

Marco, the owner, used to run the Water Bar at Colette Shop. After that closed in 2017, he opened his own place on the rue de la Sourdière. A great everyday lunchtime *cantine*.

Ebis

19 RUE SAINT-ROCH, 1ST ARR.

Best gyoza and Japanese canteen in Paris, on the rue Saint-Roch.

—*Sarah Poniatowski Lavoine*, French-born designer, founder of Maison Sarah Lavoine, and author of *Chez Moi: Decorating Your Home and Living like a Parisienne.*

A ★ means a suggestion is located in the current district.

★ Restaurant Substance

18 RUE DE CHAILLOT, 16TH ARR.

(SEE PAGE 21)

These days, my heart goes to Substance! Matthias Marc, the very very young chef of this new restaurant, has a résumé that will ravish connoisseurs. He studied under Ducasse, as well as at the Plaza Athénée, Chez Lasserre, Racines des Prés, and more. Your taste buds won't believe their luck with Marc's short yet brilliant and audacious menu. At Substance, you won't simply experience Chef Marc's passion for cooking, but also be immersed in his second one: music! His DJ set is never far from the kitchen, and DJ friends of Chef Marc's regularly come share their music with patrons. Expect classical music with your appetizer before a gradual shift to techno, funk, and jazz.

My favorite spot? Sitting at the bar to watch Matthias direct his team of handsome, talented (and tattooed!) men in perfect choreography. The cellar is also worth it: a selection of *grands crus* and lesser-known delicious wines alongside an impressive champagne selection. You must try the desserts as well!

Restaurant Les Marches

5 RUE DE LA MANUTENTION, 16TH ARR.

Les Marches, right by the modern art museum, by the water, will take you back in time to postwar Paris. The Romanesque décor of this former pit stop for truckers (because it was tasty and cheap) has barely shifted since the 1950s. Small tablecloths checkered with white and red, original tile floor, lustered woodwork, and large mirrors marked by the years gone by. All that's missing is Jean Gabin and Lino Ventura enjoying a veal's head at one of the tables. This restaurant became trendy without meaning to, simply because it provides great French cuisine, bourgeois yet homey, without pretense—a real Parisian bistro kitchen! On top of it all, the servers are young, nice, and smiley.

Chez Georges

1 RUE DU MAIL, 2ND ARR.

(SEE PAGE 158)

It's impossible to visit Paris without trying the fundamentals of French cuisine: *andouillettes* (coarse-grained sausage made with pork, chitterlings, pepper, wine, onions, and seasonings and sometimes containing tripes as well), *foie de veau* (veal liver), *rognons* (veal or lamb kidneys), *ris de veau* (sweetbread, from calf and lamb)—all meats. One of the best places for this experience, which is always peculiar for foreigners, is Chez Georges, on the rue du Mail. Red moleskine seats, immaculate tablecloths, a large zinc bar by the entrance, funny servers dressed in black with white aprons, a delicately handwritten menu . . . it feels like being in the past century—before electric scooters (*trottinettes*) appeared. Keep some room for the profiteroles, the *baba au rhum* (rum spongecake), or the delicious artisanal sorbets from Pedrone, in Vitry-sur-Seine. Top it off with a Brazilian coffee. The only downside: tourists have widely shared this Parisian address, so it's a little less secret now.

Plein Ouest

4 RUE SAULNIER, 9TH ARR.

Plein Ouest opened in July 2019, bringing raindrops from Brittany. Didier Quémener, the chef from Brittany, focuses on the best dishes from his region, which is known for both sweet and salty crêpes (the latter are called *galettes*). No long menu, but a few dishes each day depending on his fresh produce selection. Lobster, crawfish, spider crabs, and all other crustaceans are directly brought in from Roscoff fisheries. The morning catch makes it to your plate in less than twenty-four hours! Even the black angus beef is made in Bretagne, and coffee beans are torrefied (a special way of being dried and roasted) there, too. The cheese is ripened in the restaurant's cellar for anywhere from fifteen days to six weeks. Gourmets all want to try them: cheese ripened in brown beer, cider, honey, or even seaweed.

★ Waknine

9 AVENUE PIERRE 1ER DE SERBIE, 16TH ARR.

Samy Waknine's restaurant, across from the Galliera museum in the 16th arrondissement (whose legendary lethargy is slowly coming to an end) is one of my favorite Parisian fares. Samy is an old friend. We met in the eighties. We were twenty and we went out a lot, proud of getting into all the select clubs of Paris simply because we looked good and had style! In the same night, we'd hit the legendary "Bus" (Bus palladium) nightclub in Pigalle, then grab a drink at the Bains Douches, where you could cross paths with Prince or Mickey Rourke, always in good company. We would finish at the "Élysée Mat," then the "Palace," where we commented on people's looks with a young Jean Paul Gaultier. Waknine is precisely the kind of place you'd find in Paris in the late seventies to early eighties, when the atmosphere was light, fun, and carefree.

Waknine's food is delicious, but we mostly come for Samy. Always courteous, charming, seductive, and generous, he'll gracefully present you with a coffee or an appetizer to try. Samy loves hosting and you can feel it. From an empty water carafe to a slightly longer wait for your dish or a misplaced plate, Samy notices everything. The plates themselves are actually splendid. They come from Sicily and are sold at the restaurant.

Regular patrons know each other and welcome new faces warmly. Here, you won't find a designy or trendy décor, but a cozy spot, warm and welcoming, where patrons like to stick around to chat, smoke a cigarette at the terrasse, and enjoy good wine. (Oh yes, you're in France here! We smoke too much, drink more than we should, and men still smile at women!)

—FRÉDÉRIQUE VEYSSET,
French fashion photographer and coauthor of *Paris Street Style: A Guide to Effortless Chic.*

2

From the Louvre
to
the Grand Palais

Angelina

226 RUE DE RIVOLI, 1ST ARR.

Opened opposite the Tuileries in 1903 by the Austrian pastry alchemist Antoine Rumpelmayer, this iconic tea room and pâtisserie is where Marcel Proust and Coco Chanel would go for hot chocolate.

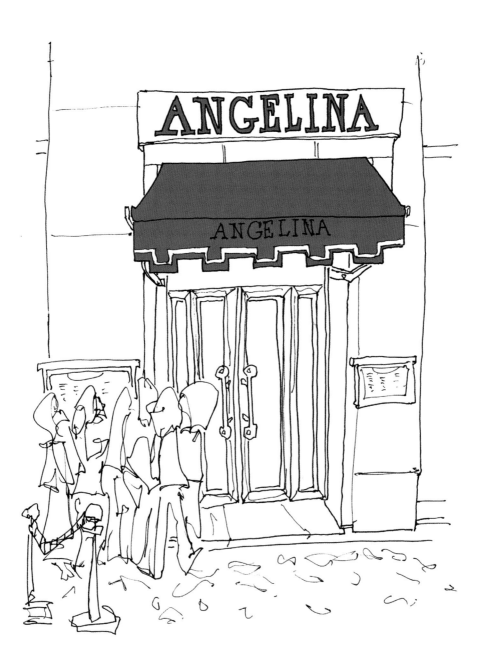

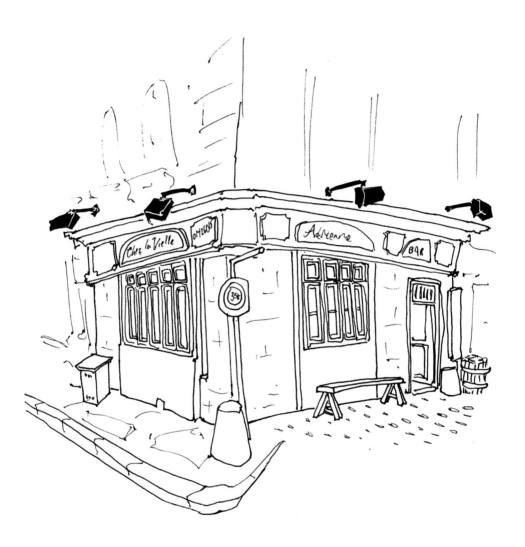

Chez La Vieille

1 RUE BAILLEUL, 1ST ARR.

In 1958, Adrienne Biasin, an opinionated chef who was ironically christened "La Vielle," or "The Old Lady," at the start of her career because she was often the youngest one in the kitchen, opened this corner spot. The surrounding neighborhood, dominated by the Les Halles food market, was, as Émile Zola labeled it, the "belly of Paris," and eventually securing a table here was next to impossible. Biasin, who became something of a legend, passed away in the 2000s, and the neighboring food market has moved to a new location. But in 2016, the American restaurateurs Daniel Rose and Stephen Starr took over Chez La Vielle and made it their mission to revitalize the establishment and honor its history (and, in doing so, proving that nostalgia is a dish best served warm).

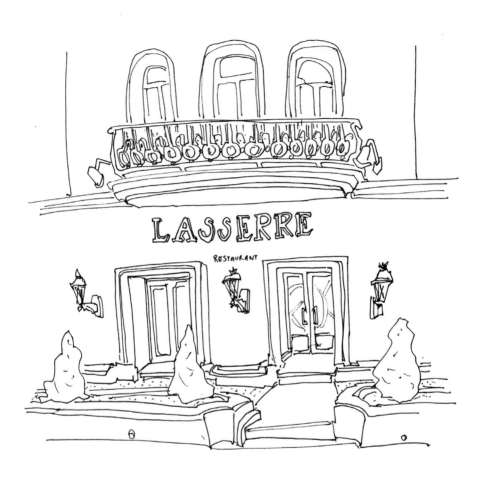

Lasserre

17 AVENUE FRANKLIN DELANO ROOSEVELT, 8TH ARR.

A classic, old-school experience with a twist. The roof here is retractable and on clement nights it opens to the Parisian sky.

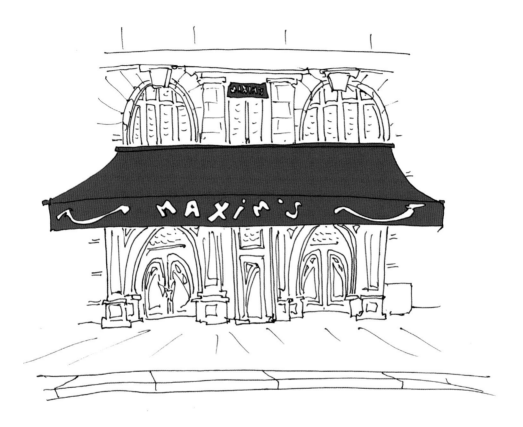

Maxim's

3 RUE ROYALE, 8TH ARR.

During the middle of the last century, this art nouveau oasis was where the international jet-set rested up in Paris. Once regarded as the city's most famous restaurant, it's become an icon around the world, appearing in Hollywood films and spawning locations in Tokyo, London, and beyond.

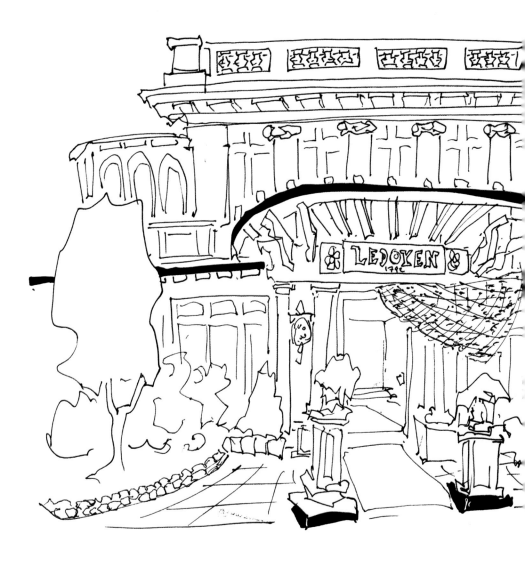

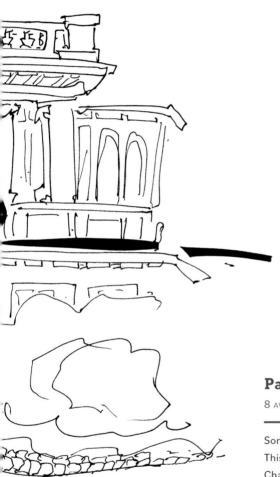

Pavillon Ledoyen

8 avenue Dutuit, 8th arr.

Some spots have three Michelin stars.
This neoclassical addition to the
Champs-Élysées Gardens has a trio of
Michelin-starred eateries—Yannick Alléno's
main dining room on the first floor, which has
three; L'Abysse sushi counter, which has two;
and Pavyllon, a counter space, with one.

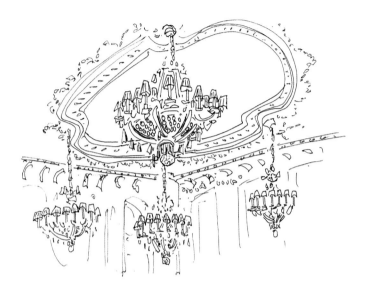

Crystal chandeliers line the ceiling here.

Restaurant le Meurice Alain Ducasse

228 RUE DE RIVOLI, 1ST ARR.

Haute cuisine in a royal setting. The mirrored and chandelier-filled room was inspired by the Salon de la Paix in the Château de Versailles (as seen through the eyes of Philippe Starck).

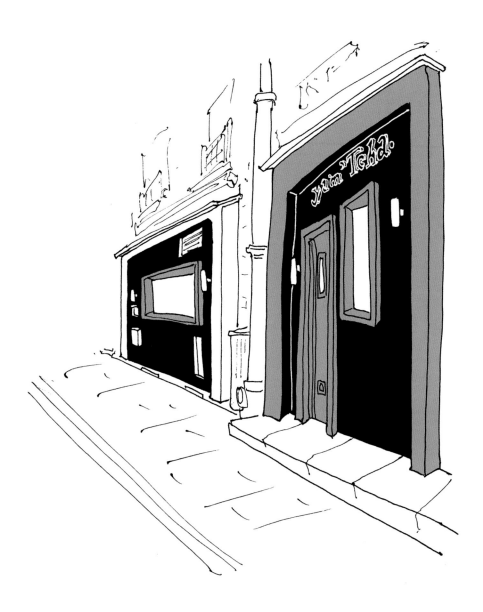

Yam'Tcha

121 RUE SAINT-HONORÉ, 1ST ARR.

Asian-inspired, Michelin-starred cooking and tea pairings make for an unforgettable experience.

In Paris, my must-visits for each trip are:

Les Petits Mitrons

26 RUE LEPIC, 18TH ARR.

The family-run bakery Les Petits Mitrons on the rue Lepic for a few slices of fruit tart. (My favorite is the *fruits rouges et abricot*, or the rhubarb.) I especially love the caramelized edges!

★ Télescope Café

5 RUE VILLÉDO, 1ST ARR.

Télescope Café to check in with my friend, owner Nicolas Clerc, and to have a perfect coffee and a few slices of his house-baked bread. It's a great place to meet new people, too, as the cast of characters is always interesting and stylish, thanks to Nico.

Chez Virginie

54 RUE DAMRÉMONT, 18TH ARR.

Chez Virginie is a delightful cheesemonger, passed from father to daughter. While I prefer the original location on the rue Damrémont for the higher probability of sighting Virginie herself, the newer one at 125 rue Caulaincourt is great, too. I learned about it from a friend who would have the taxi stop there and wait while he stocked up on his way home from CDG. Virginie's timing and sense of what to serve when are always perfect.

Déviant

39 RUE DES PETITES ÉCURIES, 10TH ARR.

Déviant is so un-French, and yet perfectly French. The standing-room-only, no-doors natural wine bar—opened by the brilliant chef Pierre Touitou of neighboring Vivant 2 (another staple)—serves small, affordable plates of flawless food, but makes it feel like a super-cool party that you somehow managed to crash. Open late—always a bonus.

—CHRISTINE MUHLKE is the founder of the *Xtine* newsletter. The former *Bon Appétit* and *New York Times* editor often reports on Paris's food scene from her apartment in the 18th arrondissement.

A ★ means a suggestion is located in the current district.

Brasserie Lipp

(SEE PAGE 86)

This is my favorite Sunday-night dinner . . . traditional roasted chicken and true French fries. The waiters wear white, and no cell phones allowed. In the heart of St Germain.

Le Perron

6 RUE PERRONET, 7TH ARR.

My favorite Italian food in Paris. A cozy, intimate room with homemade pasta and an excellent wine list. Just off the boulevard Saint-Germain in the 7th arrondissement.

★ Kong

1 RUE DU PONT NEUF, 1ST ARR.

The most dramatic location in a glass-domed aerie above the Seine. Great cocktails and adventurous dining.

—GLEN BALLARD,

a six-time Grammy-winning producer and songwriter whose credits include Alanis Morissette's "Jagged Little Pill" and Michael Jackson's "Man in the Mirror," lived in Paris for a year while working on *The Eddy*, his 2020 Netflix series about an American jazz pianist living in Paris.

3

In and About Le Marais

Benoit

20 RUE SAINT-MARTIN, 4TH ARR.

This fabled bistro opened in 1912 and was in
the same family from its founding until 2005,
when the famous French restaurateur Alain
Ducasse took it over. He has since opened
Benoits in New York and Tokyo.

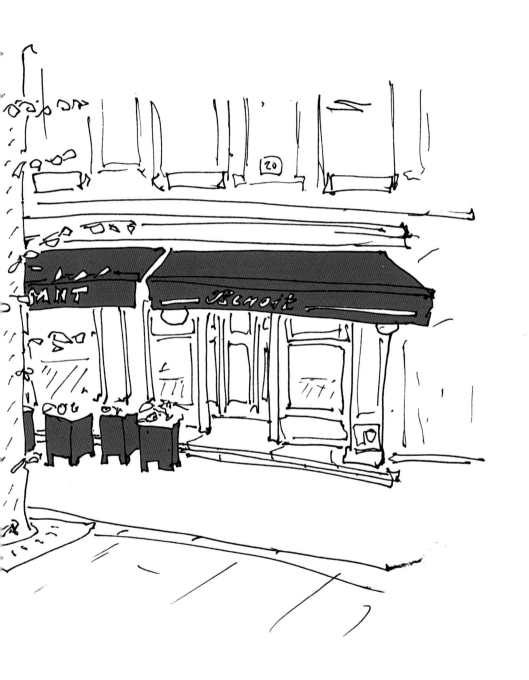

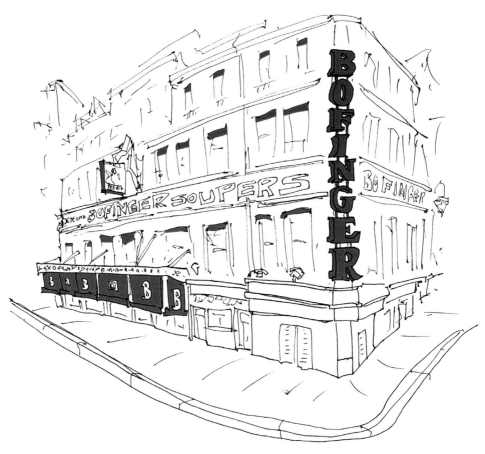

Bofinger

5–7 RUE DE LA BASTILLE, 4TH ARR.

My boyfriend took me to Bofinger for a birthday meal, following a recommendation from a friend. Being a Londoner myself, I am used to a vast array of cuisines, so my only request was French, French, French, and snails.

When I saw the outside, which is rather unassuming, I began to panic that I was severely overdressed and was about to stand out like a sore thumb in my dress and heels. (To be honest, though, this would be acceptable anywhere in Paris.)

Plates at the ready in Bofinger's dining room.

However, I had nothing to worry about. I can only describe the experience of entering the gorgeous space as like walking into a TARDIS, the time-and-space-travel machine from *Doctor Who*.

The food, wine, and service were impeccable; however, it was the numerous worlds that had come together inside Bofinger on that night that really captured my attention. We saw a newly engaged couple, a gaggle of girls, parents catching up with their grown-up children, and old couples who have probably reserved the same seats for the last thirty years.

To me, going out for a meal should be a celebration that happens to be paired with great food. Bofinger epitomizes this, and I had a smile on my face from the moment we arrived to sometime after. It felt like an occasion without being pretentious. So, thank you to the friend who recommended it, and to my boyfriend, who also gave me quite a nice view to look at across the table. We will be back!

—PHOEBE GREGORY,
a London-based headhunter in the technology industry who loves both traveling and good food.

Breizh Café

109 RUE VIEILLE DU TEMPLE, 3RD ARR.

You could travel to Brittany for a savory *galette de sarrasin* (loosely speaking, a buckwheat crêpe), or you could head to the Marais for the original outpost of this beloved multi-location café.

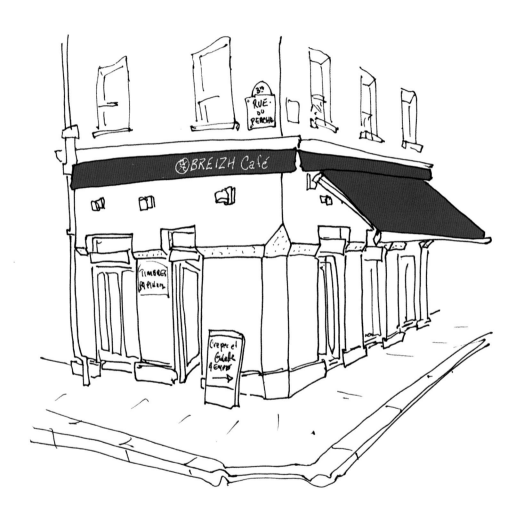

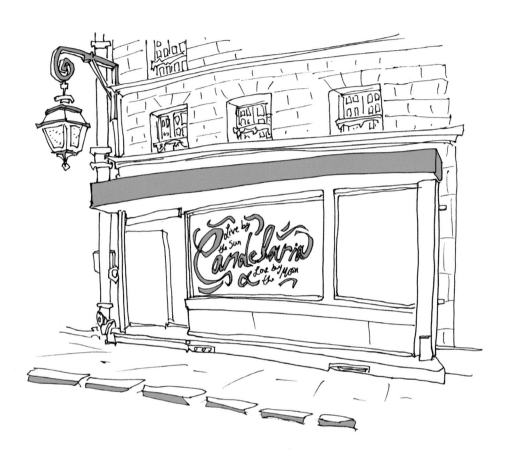

Candelaria

52 RUE DE SAINTONGE, 3RD ARR.

Paris's first authentic Mexican taqueria opened to long lines in 2011. The attached cocktail bar is regarded as one of the best in the world.

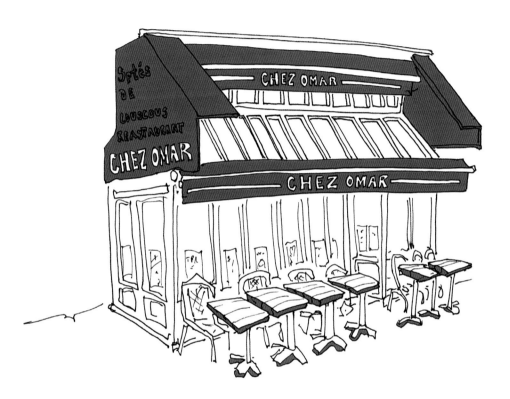

Chez Omar

47 RUE DE BRETAGNE, 3RD ARR.

Couscous, couscous, and more couscous.

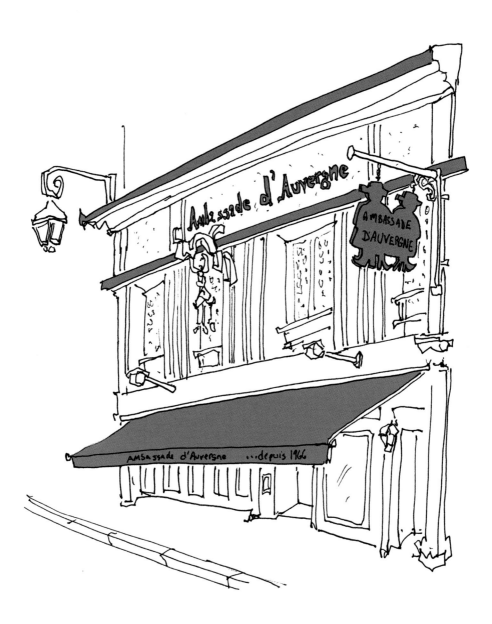

L'Ambassade D'Auvergne

22 RUE DU GRENIER-SAINT-LAZARE, 3RD ARR.

In the comfortable rustic surroundings of L'Ambassade D'Auvergne, I came face-to-face with a young woman I'd not seen in three months. Not such a long time in the scheme of things, but in my daughter's young life, those three months represented a tremendous period of growth: time spent navigating the world on her own during a study-abroad semester in Paris.

I had just arrived to spend a week as a *flâneuse* in the city, while she worked at an internship during the days. I wanted a special meal to kick off our week, so I got a list of recommendations from my hotel. L'Ambassade D'Auvergne offered a selection of traditional Auvergnat dishes. Our family had spent a week in the Auvergne a few years earlier, so we would be familiar with the menu.

We wandered over through a November drizzle, ducking into some stores but still managing to arrive a bit early for our reservation. We were wet and bedraggled, and rather dismayed to be seated in the window for all of fashionable Paris to see. And—*quelle horreur!*—there was a mirrored corner wall to reflect our dishevelment back at us ad infinitum! But what that mirror also reflected was my child, her curls tipped with mist from our walk, her eyes wide as we shared adult beverages together for the first time.

I wanted a restaurant where we could relax in comfort and I was not disappointed. The sign outside L'Ambassade D'Auvergne told us it had been established in 1966, although we later learned that the original owners had since retired. The upstairs was decorated with photographs

A pre-dinner place setting at L'Ambassade D'Auvergne.

of what I assume were the region's Aubrac cattle. The rooms were warm with dark exposed timbers, but the mood was light as the maître d' teased my daughter and she responded in French.

The menu is based on the fierce traditions of the Auvergne region, heavy on meat courses but fortunately with options for those of us who don't eat meat. I was thrilled to find my favorite dish, *lentilles vertes du Puy*, and even happier when my daughter ordered me a Verveine du Velay aperitif. Proustian memory was evinced with each bite I took; the legumes transported me back to a sunny square in Le Puy, to a dinner with this same daughter years younger blowing bubbles in her Orangina and making her brother giggle. But even as I devoured the essence of past meals, the present moment was etched in sharp relief as my daughter sipped her wine before me.

My meal came with a serving of the regional specialty, pommes aligot. Mashed potatoes don't usually define a dining experience, but these were dollops of cheesy goodness, a purée blended with very, very melty regional cheese. The waitstaff made a big show of stirring and stretching and serving the aligot with long, luscious pulls at each table. We shared dessert, a generous portion of smooth chocolate mousse.

It was enough. It was more than enough. For someone like me, for whom food is generally not a priority, the meal remains a treasured memory. Comfort of food and place coupled with the marvel of getting to know the independent young woman my child had become. The aligot was amazingly elastic and my heart stretched to bursting.

—SUE MORRIS,
who writes online about nineteenth- and early-twentieth-century Pittsburgh history as the Historical Dilettante and is a museum docent at the Frick Pittsburgh, has visited Paris five times.

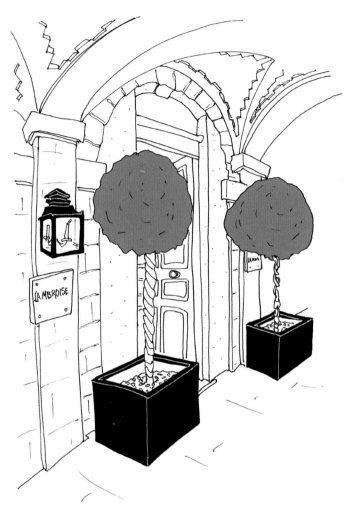

L'Ambroisie

9 PLACE DES VOSGES, 4TH ARR.

The name of this beloved traditional French restaurant comes from Greek mythology describing the "food of the gods." Perhaps because higher beings presumably get to choose what they want to eat, there has never been a tasting menu here. There have, however, been Michelin stars. Three of them each year for more than thirty years.

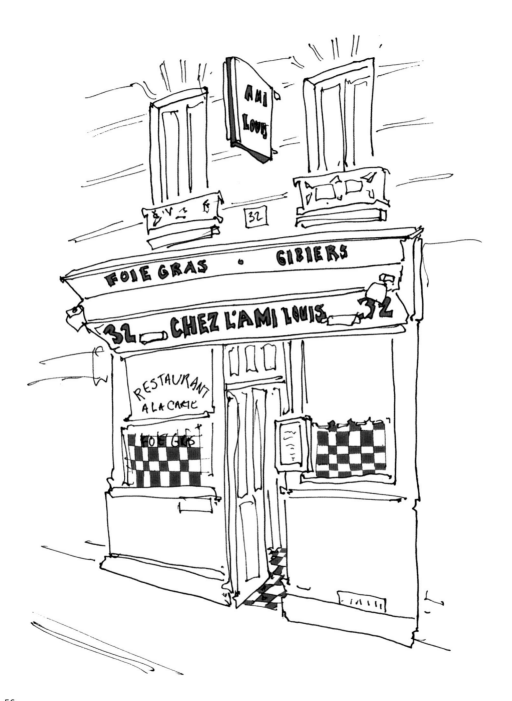

The centerpiece of the cozy dining room is an ancient stove.

L'Ami Louis

32 RUE DU VERTBOIS, 3RD ARR.

This classic old bistro is my favorite restaurant in Paris. When Thomas Keller and I were traveling through France and writing the *Bouchon* cookbook, we ate at as many varied bouchons—classic Lyonnaise bistros—as possible. They all serve the same food, and I was getting really tired of *andouillettes* and the like. When we hit Paris, Keller took us, the whole cookbook team, here for escargot and roasted chicken (black feet still attached) and foie gras. It was sublime. The only caveat is that it's got to be the most expensive "bistro" on the planet.

—*MICHAEL RUHLMAN*
is a writer who lives in New York City and Providence, Rhode Island.

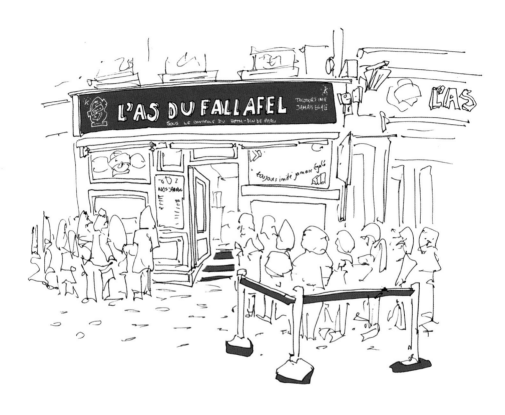

L'As du Fallafel

32–34 RUE DES ROSIERS, 4TH ARR.

There's almost always a line here for the falafel, and for good reason.

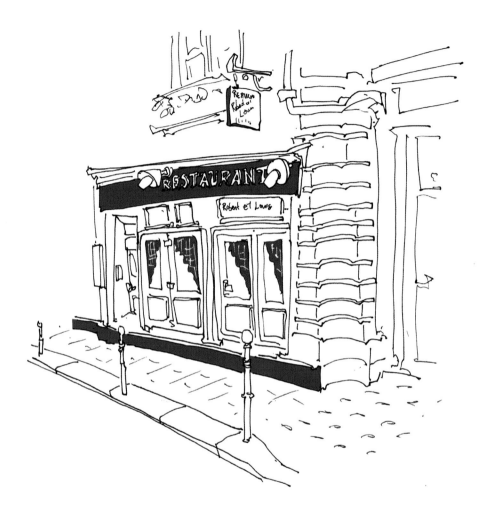

Robert et Louise

64 RUE VIEILLE DU TEMPLE, 3RD ARR.

Open since 1958, this restaurant's eponymous Robert and Louise are long gone (one of their daughters, Pascale, and her husband, François, run it now), but the wood fire and grilled meats (*entrecôte!* leg of lamb! duck breast!) that gave the late Anthony Bourdain conniptions of pleasure when he first encountered them remain.

La Fée Verte

108 RUE DE LA ROQUETTE, 11TH ARR.

★ Café Charlot

38 RUE DE BRETAGNE, 3RD ARR.

Wild & The Moon

MULTIPLE

My years in Paris have essentially come down to a hunt for the perfect café in which to work for a few hours. When I first moved here, I discovered **La Fée Verte,** on the rue de la Roquette in the 11th arrondissement. I liked its curved zinc bar and mosaic floor, and the fact that its name—the green fairy—refers to absinthe. Also, since it looked straight out of a Jean-Luc Godard film, I imagined that fascinating strangers would speak to me. No one ever did, but I finished my first book there.

More recently, Paris has become a city of efficient *coworking* spaces: You pay twenty euros per day for a desk and all the mediocre coffee you can drink. But I still prefer to bring my laptop to cafés. The buzz of people reminds me of a newsroom, or at least the newsrooms you see in movies (actual newsrooms often resemble the cubicles and quiet of coworking spaces). I like catching snippets of conversations and of people's lives.

Some cafés—and even specific tables— seem to have magical properties. For several years I worked at the second to last banquette at **Café Charlot,** in the Marais. I thought I might be imagining that it was a kind of creative vortex, until I noticed that another woman was angling to work there, too. "The second table!" she waxed, when we finally discussed it.

Most days, I leave my café just before the lunch rush, then go someplace else in the afternoon. I'm not snobbish about my choice. For a while I got a lot done at the shared wooden table at my local Le Pain Quotidien—the Belgian chain. I stopped going when a mouse regularly scuppered under my feet, but the waitstaff seemed unconcerned.

After that I tried a vegan juice bar, **Wild & The Moon**. But I was spending a fortune on smoothies, and there were too many beautiful fashion people talking about *le marketing*.

Mamma Primi

71 RUE DES DAMES, 17TH ARR.

Blue and pink seats, a squeaking wooden floor, a profusion of plants, and onion sheaves . . . here, the staff speaks with a welcoming Italian accent. If the tables are filled for lunch and dinner, it's because of the incredible selection of products and wines directly imported from Italy: bresaola, burrata, smoked stracciatella, bruschetta, Parma ham . . . everything else is homemade, including the pasta! Of course, the pizza is delicious, too. You can also opt to sit at the terrasse until the end of the night.

★ Florence Kahn

24 RUE DES ÉCOUFFES, 4TH ARR.

A small family business, this Yiddish caterer in the heart of the Marais has not changed in years. The staff is still as friendly, and its iconic blue mosaic façade was officially designated a historical monument in Paris. Must-tries are the liver with onions, the "taramour" (a playful amalgam of *tarama* and *amour*—fish eggs and love), the marinated herring, the red pepper compote, the generous pastrami sandwich, the poppyseed bagel, and for desserts: the chef's take on a cheesecake or the apple strudel. In summer, come early to sit at the terrasse and relax while enjoying the food.

—ISABELLE THOMAS,
French personal stylist, journalist, fashion expert, and coauthor of *Paris Street Style: A Guide to Effortless Chic.*

★ Bontemps Pâtisserie

57 RUE DE BRETAGNE, 3RD ARR.

The sablé, a buttery shortbread, reaches creative heights at this family-run specialty shop that riffs on the classic cookie. Bite-size cookies are stuffed with fresh cream-based fillings (my favorite is the caramel banana flambé) while the sablé crust is used as the base for a variety of exquisite tartes, from lemon to comice pear and a to-die-for Mont Blanc.

★ Le Mary Celeste

1 RUE COMMINES, 3RD ARR.

One of my go-to hangouts for creative cocktails, affordable natural or biodynamic wines, and fish-forward small plates. The bar-restaurant has a breezy, California sensibility and terrific service.

La Liquiderie (Cave)

9 RUE DES TROIS BORNES, 11TH ARR.

Craft beer is no longer niche in Paris! This is a tiny bottle shop in the 11th arrondissement that specializes in European and American craft beers and natural wines. It's the perfect spot to visit before an aperitif-picnic along the nearby Canal Saint-Martin!

★ Centre Pompidou

PLACE GEORGES-POMPIDOU, 4TH ARR.

I couldn't imagine being in Paris for any amount of time and not stopping by the Centre Pompidou. I love it both inside and out, and the out famously shows the insides. To encounter it for the first time is to confront an architectural beast, this breathtaking Renzo Piano and Richard Rodgers utopian seventies behemoth, all structure and glass. And once inside you realize it's not just a museum of massive collections and gorgeous exhibitions, but a kind of art village, with cinema theaters, music and dance shows, and a huge public library full of students from all over the world. And don't miss maybe my favorite view, from the upper floor after ascending through the glass escalator. It's a great vantage point in which to contemplate Paris, and there's even a cool rooftop restaurant up there with you.

—*Richard Linklater,*
filmmaker, director of *Before Sunset*, set in Paris.

—*Lindsey Tramuta,*
journalist and author of *The New Paris* and *The New Parisienne.*

4

Latin Quarter
and
Île Saint-Louis

Au Coin des Gourmets

5 RUE DANTE, 5TH ARR.

Virginie Ta, who left Cambodia in 1973, and her family serve the food of her homeland, as well as Laos and Vietnam, in a cozy space. Sometimes spring rolls, papaya salad, and pho are just what you want.

Baieta

5 RUE DE PONTOISE, 5TH ARR.

Julia Sedefdjian, the youngest chef to ever earn a Michelin star (at age twenty-one, at Fables de la Fontaine), opened her own place in 2018. The name means "little kiss" in the dialect of her native Nice, and her love of good food shines through in the fantastic dishes she serves.

Berthillon

29–31 RUE SAINT-LOUIS EN L'ÎLE, 4TH ARR.

Ice cream. Need I say more?

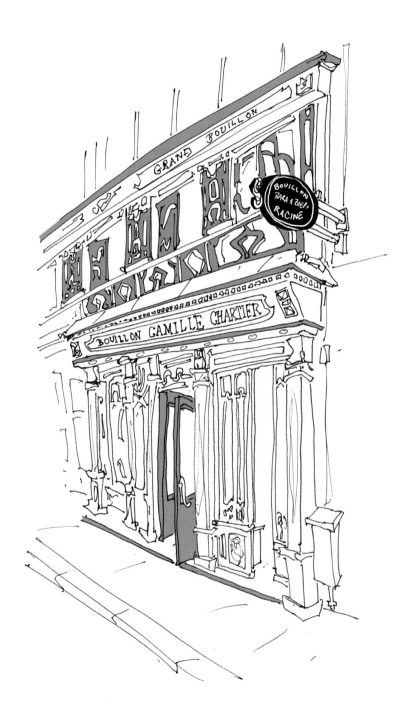

Bouillon Racine

3 RUE RACINE, 6TH ARR.

It was the day after Christmas a few years ago, and my friend Alex and I spent it wandering around Le Marais, trying not to gawp at the absence of a Boxing Day break that we were accustomed to in our native Sydney. It started to rain just as we left for dinner, so we wrapped up in layers of wool—jumper, scarf, gloves, beret, and coat. Paris in the rain loses all sense of time and history, and when we made it to Bouillon Racine for dinner, it almost felt like 1906, which is when it was established.

It was the most beautiful restaurant we visited, with its soft sage-green paint job, art nouveau vines curling around the walls, and warm lighting bouncing off the mirrors. We had a coupe de champagne to begin with, which went perfectly with our escargot (our habit is to order six and split them, sopping up the garlic butter with bread and teasing each other over who is the worst at removing them from their shells), which were tender and bursting with flavor. "Who was the first person to decide to put butter, garlic, and snails together?" asked Alex. "And where is their shrine?"

We moved on to a 2017 Menetou-Salon, Les Bornés Domaine Pellé, which was warming and far too easy to drink. It went perfectly with my plat du jour of duck confit with pomme purée. Our meals were unpretentiously presented, which is one of my favorite things about French food—it rarely relies on tricks to impress you. Alex had pork ribs from Picardie, which smelled delicious. Both of us oohed and ahhed as the meat fell off the bone, and the rain roared outside.

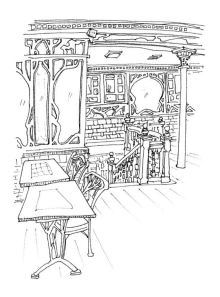

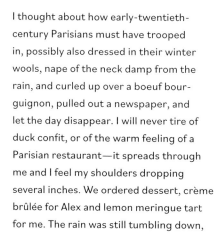

The upstairs dining room.

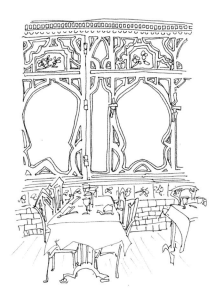

Art nouveau mirrors line the walls at Bouillon Racine.

I thought about how early-twentieth-century Parisians must have trooped in, possibly also dressed in their winter wools, nape of the neck damp from the rain, and curled up over a boeuf bourguignon, pulled out a newspaper, and let the day disappear. I will never tire of duck confit, or of the warm feeling of a Parisian restaurant—it spreads through me and I feel my shoulders dropping several inches. We ordered dessert, crème brûlée for Alex and lemon meringue tart for me. The rain was still tumbling down, so we had another glass of wine, and Alex took advantage of the deeply flattering light to take photos of me laughing like a fool. Then we piled our woolen layers back on—jumpers, scarves, coats, berets, gloves—and tottered home, the warmth of Bouillon Racine tucked neatly inside us.

—MADDIE BARTON,

a French-literary bookworm from Sydney, Australia, was on her third trip to Paris.

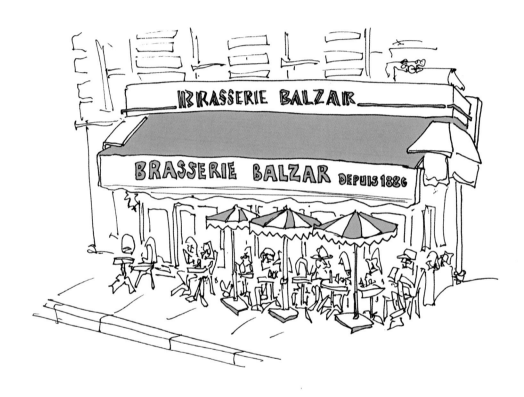

Brasserie Balzar

49 RUE DES ÉCOLES, 5TH ARR.

Since 1866.

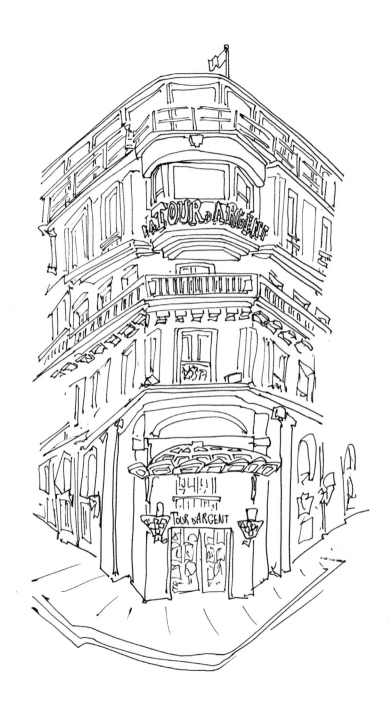

La Tour d'Argent

17 QUAI DE LA TOURNELLE, 5TH ARR.

The "Silver Tower" has quite a glittering history. Food has been served here for more than four hundred years, and in the late sixteenth century, this is where Henry IV first encountered the fork. Today, it's holding on to a Michelin star, and the views from its upper floors can't be beat (especially at lunchtime, when the cityscape can be appreciated in the light of day—and the lunch prices are always a better value, too).

Le Saint Régis

6 RUE JEAN DU BELLAY, 4TH ARR.

It's easy to go wrong in a town like Paris
that draws so many tourists. Le Saint Régis,
idyllically situated on the Île Saint-Louis
steps from Notre-Dame and graced with
checkerboard-tiled floors, uniformed waiters,
and savory bistro fare, will set you right.

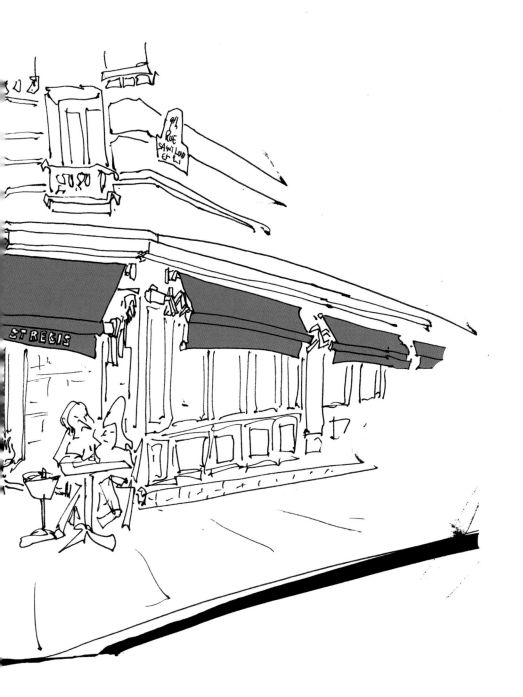

★ Coutume Institut Coffee

60 RUE DES ÉCOLES; 33 RUE SOMMERARD, 5TH ARR.

★ Hugo & Co

48 RUE MONGE, 5TH ARR.

La Bourse et La Vie

12 RUE VIVIENNE, 2ND ARR.

We dedicated every morning of our time in Paris to looking for great coffee and we landed on **Coutume** as our favorite. It has locations around the city, but Coutume Institut is the best of all: It's set in the back of the Institut finlaindais (Finnish Institute) and feels a bit like a secret; you could walk right past it without knowing it's there. The space is incredible: sunny, with soaring ceilings and Scandinavian décor—it's such a calm place to spend half an hour before you start your day. I really have only one complaint: The sugar dispenser had a sign on it that said something like "Have you tried it without sugar first?" I don't love being sugar-shamed by my barista!

We felt most like locals when we ate at **Hugo & Co**, in the Latin Quarter. The mood was super festive, the room was bustling, and the menu was a nice break from our usual Paris diet of heavy French food. My kids were just done with baguettes and ham by the time we got there, and they were so happy to dig into these small plates. The chef, Tomy Gousset, is a master of layering flavors. I feel like you could go back again and again and never get bored. Bonus points for delicious cocktails!

La Bourse et La Vie was the ultimate test of our parenting skills: Would our white-bread-and-pasta-loving kids really be able to handle dinner at a proper, intensely French restaurant? The girls (six and nine at the time) survived, and housed the steak frites and pot-au-feu and pretty much everything else that came to the table. I think I can confidently say that my girls became lovers of French food at this very restaurant, so thanks to Daniel Rose for that.

—Maile Carpenter,
editor in chief, *Food Network Magazine*.

★ Solques Bruno

243 RUE SAINT-JACQUES, 5TH ARR.

There's this charming little boulangerie owned and run by a man named Bruno Solques that I love telling people about. It's in a quiet part of town, away from the touristy crowds but not *too* far away. (It's just a couple of blocks from the Luxembourg Gardens.)

What makes this place so special is that not only are the pastries, bread, and quiches super delicious, unique, and even organic . . . but the shop is filled with Bruno's ceramic sculptures. He creates these amazing animal heads, floral bouquets, bowls of fruit—all out of clay. He even makes the ceramic platters that display the pastries. When you step off the street into Bruno's shop, there's this magical, unexpected feeling of stumbling into an artist's studio, and I love that.

—*Eva Jorgensen*

is a creative director, lifelong Francophile, and author of *Paris by Design: An Inspired Guide to the City's Creative Side* (Abrams 2019). She lives with her family in the Utah mountains and travels as much as possible—especially to France. Find her online at sycamoreco.com and on Instagram at @sycamore_co.

5

ST GERMAIN

Allard

It all started in the autumn of 2017. I'm a senior brand manager at a high-end US cheese producer, and we were launching an annual dinner at Restaurant Daniel in New York called "La Celebration du Fromage." That night, I invited an acquaintance named HK to come. During the dinner, he mentioned that he was going to a wine tasting in Burgundy the following month. He wanted to meet in Paris for dinner. Without hesitating I told him, "Name a date, hour, and place, and I will be there."

I'm sure he assumed that I was joking around and would never go to Paris for one dinner. Still, a few weeks later he called to give me the date and time and to discuss the place. I told him I would be there. Then I called two French friends living in Bordeaux and Brittany to meet up for this dinner as well. Why not, right?

HK, who wanted to have a real, traditional French experience, chose Allard. Knowing the establishment has been around for a very long time and is owned by Alain Ducasse, we were excited. HK was astonished when we showed up. We ended up having one of these memorable nights where you eat like it's your last meal. We started with escargot and grenouilles, and we continued with their original roasted chicken and duck with oven-baked potatoes and green beans and more. We bonded and laughed and made a friendship that night which will never be broken because "we showed up." That night will remain with the four of us forever because it was so special.

The following year, I decided to go back to Allard with my wife. We were seated in a different dining room than the one I ate in with my friends. The atmosphere was very cozy and romantic, and the night was exactly what I hoped for, which was a pure delight and again a great culinary experience. We shared *baba au rhum*, which was presented to us with three different types of rum for us to choose to our liking.

An open kitchen greets visitors to Allard,
and divides the space into two dining rooms.

At one point, my wife went to use the bathroom, and coming back she was amazed to see inside all the signatures of famous people who once dined at the same tables. We knew the place was around for a long time, but to see famous names like Charlie Chaplin showed again what a jewel this place is. We went back to the hotel, happy, full, and both grateful.

Last year, my wife and four-year-old daughter joined me on a work trip to Paris. I am French originally, and I asked my mum to come from the south of France to spend time with us. That time, I decided to take the whole family for lunch, as it is easier to manage a child at the table during the day. As on my previous visits, everyone devoured their food, shared stories, and we were plunged into a different epoch where time stopped, where you can spend the afternoon around the table and wish this moment would never end. An afternoon of amazing food, amazing wine, amazing service, amazing atmosphere, all shared with people you love.

—SEBASTIEN LEHEMBRE,
who was born in Paris, raised in St. Tropez, and is now based in the States, visits his native city a few times a year for business and pleasure.

A table awaiting diners at Allard.

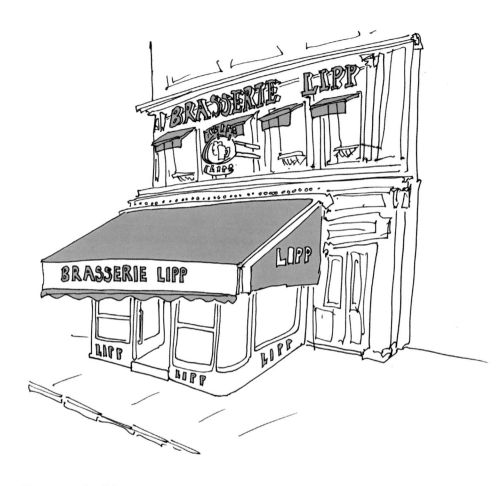

Brasserie Lipp

151 BOULEVARD SAINT-GERMAIN, 6TH ARR.

My late husband was a man named Sasha Petraske. He started a New York bar called Milk & Honey, which kind of put craft cocktails on the map. He passed away when he was about one chapter into a book he was working on. As a writer myself, I took on the project because, you know, that's what you do for someone you love. You finish their sentences for them. Phaidon published the book, *Regarding Cocktails*, and it's now in four languages, including French.

Right after I submitted the manuscript, I was debating whether I wanted to stay in New York or move to French Polynesia. I wanted to do something extreme. I settled on LA, but only stayed for two years. LA just never felt right. Paris was always my second-favorite city next to New York, but I didn't really want to transfer my grief to the Paris that I loved—running away to Paris at any random moment held so much more appeal. There was a point when I was going there once a month, or every other month.

The book ended up in my favorite bookstore in Paris in the Marais, La Belle Hortense. It's a bookstore/wine bar/restaurant and really beloved by the most colorful local characters. Everyone perched at the bar is a writer, an artist, a muse, or a philosopher. It really feels like the way Paris used to be, and the way, of course, Brasserie Lipp used to be, or any of those places where the existentialists used to meet for their apricot cocktails. I became very good friends with a man behind the bar at La Belle Hortense, Emmanuel de Salm. It became so that every time I went to Paris, Emmanuel and I were always picnicking on the Seine or having comfort meals at different restaurants.

A while ago, a friend and writing colleague of mine from the *New York Times* was turning fifty. I thought, what better reason to come out to Paris than to celebrate his landmark birthday? Before the festivities, I met my friend Emmanuel at Brasserie Lipp and we had a lovely meal there with escargot and perfectly paired wine. It just felt so comforting. I love how everyone in the past has their own table there, kind of like how we have in New York at the 21 Club. We sat next to where Simone de Beauvoir used to write, beneath the beautiful bird painting on the ceiling. It was a lovely experience. I had never actually dined there, but I'd always wanted to.

And the service was so warm and congenial. The waiters in their oxfords and bow ties carrying themselves with such grace—it's just such classic French service. You really feel like you stepped into a portal of time. It's so crazy that Emmanuel and I had never experienced Lipp. We always had gone to Café de Flore and Deux Magots, which are also in that triangle of where the existentialists used to go. But I would say Brasserie Lipp has something so intimate about it, more so than the other two. I could easily see myself whiling away the afternoon working on my next book and meeting up with my friends there as well.

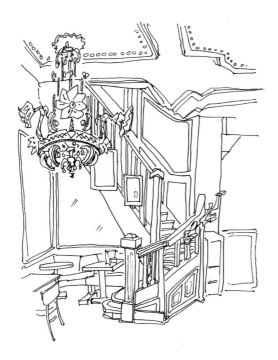

The stairs to the upper rooms at Brasserie Lipp.

I moved back to New York from Los Angeles in April of 2019. Since then I haven't been jumping on planes to Paris as much because I don't really need to. I feel more settled. New York was just a very hard place for me to be after my husband passed away. They say you can't run away, but you definitely can. I've always felt that if you can't change your history, you can change your geography for a time. I'm forever in debt to Paris for helping with the healing process. There is something about the city. It embraces a young widow,

saying, "Tell me a love story and let's share some wine."

—GEORGETTE MOGER,

a New York–based journalist and author, first visited Paris with her high school honors literature class. Over the years, she returned frequently, including during a stop on the Orient-Express while on her honeymoon. After the sudden death of her husband, in 2015, it became a second home.

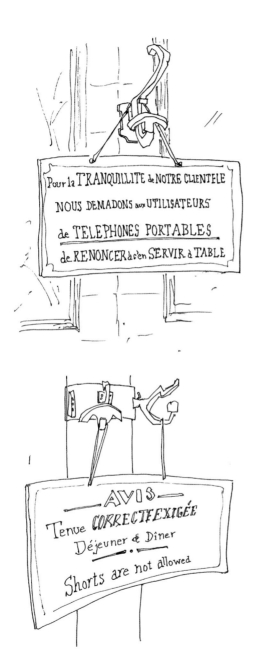

No phones or shorts at Brasserie Lipp,
in case you were wondering.

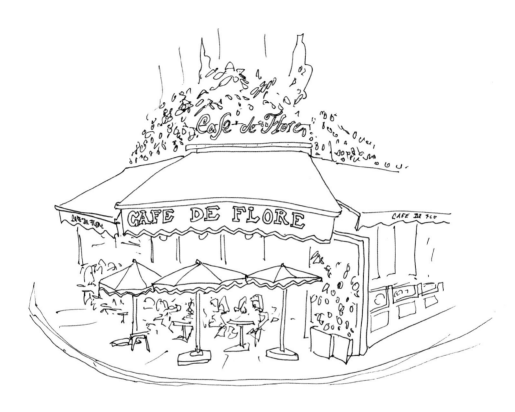

Café de Flore

172 BOULEVARD SAINT-GERMAIN, 6TH ARR.

The poet Guillaume Apollinaire took his coffee here, and it may even have helped him coin the word *surrealism*, which he first used in the program notes to the avant-garde ballet *Parade*, in 1917.

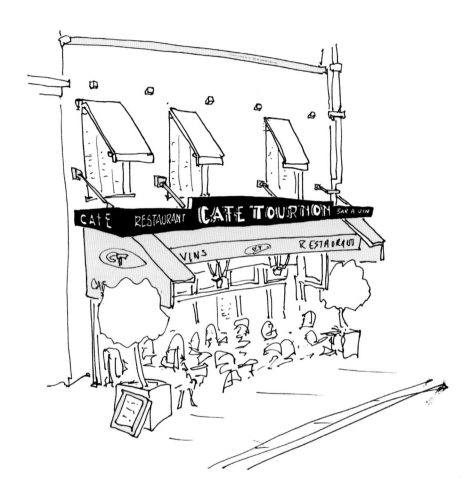

Café Tournon

18 RUE DE TOURNON, 6TH ARR.

As fine a spot as any for a quick café today, this spot was popular with African American expatriates during the last century. Duke Ellington made his Paris debut here, and Chester Himes, James Baldwin, and Richard Wright, who at one point lived nearby, all frequented it.

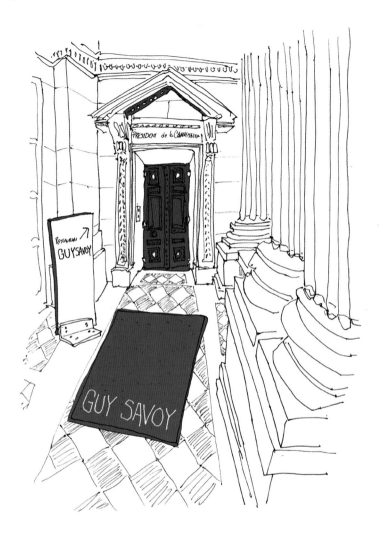

Guy Savoy

MONNAIE DE PARIS, 11 QUAI DE CONTI, 6TH ARR.

Six dining rooms, three stars, and that it's housed literally in a mint is not the whole story. At lunch they save five seats for a special three-course menu for a mere 130 euros. Book that online and as early as possible.

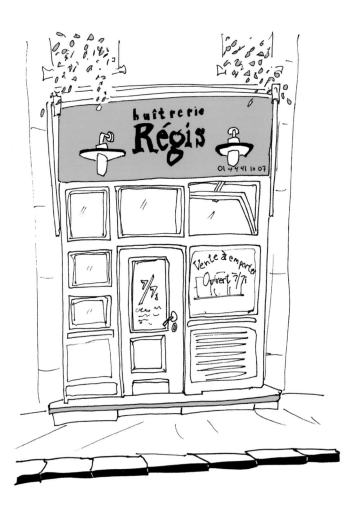

Huîtrerie Régis

3 RUE DE MONTFAUCON, 6TH ARR.

Where Ruth Reichl goes for bivalves.

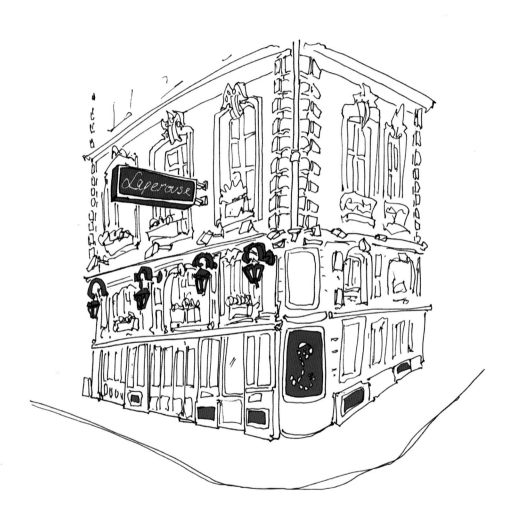

Lapérouse

51 QUAI DES GRANDS AUGUSTINS, 6TH ARR.

I was in Paris for a work trip a couple of years ago. When I discovered that some of my friends were going to be there at the same time, we started looking for a cool new restaurant. This was during Fashion Week, and because one of my friends works at one of the big fashion houses, we wanted to go somewhere fabulous. I asked a colleague who lives in New York but is from France, and knows Paris very, very well, for recommendations.

She mentioned that Lapérouse had recently reopened, and that it had all this crazy history. She's told me about, and I don't know if it's true, an underground secret entrance from the Senate, or the equivalent of the Senate, and the senators could come with their mistresses and dine in private. That the mistresses were really courtesans and they were paid in diamonds. She said they used to scratch the mirrors with the stones they were given to test their value. All sorts of scandalous stories like that.

It sounded very cool and unusual to me, and we also knew that a new lipstick ad campaign was being shot at the restaurant. It sounded decadent and lush, so we decided to go there for dinner. We anticipated that the restaurant would be chic and a real scene. That's what we expected, but then when we walked in it was the opposite, and I was like "Where is everybody?"

But it turns out it was so quiet because it's all private rooms. We were ushered upstairs to our own private space, where the five of us dined on caviar and lobster and other decadent treats. The waiters and waitresses were as beautiful as the ornate surroundings, and they told us more crazy stories about what used to happen at the restaurant. It was just like being in a grand old Parisian movie.

—SUNG PAK,
an executive at a global luxury beauty company, visits Paris several times a year.

One of the mirrors scratched by nineteenth-century courtesans.

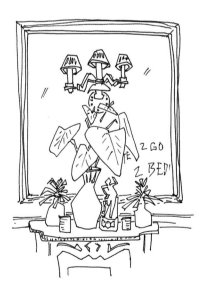

On the main floor by the bar, Kate Moss etched her intentions to stay up. "2 late 2 go 2 bed," it says.

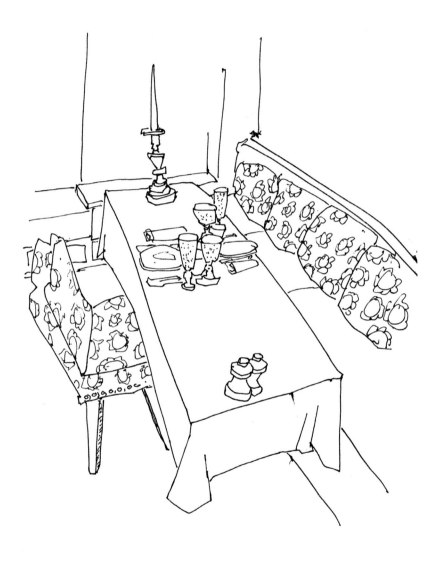

An establishment of private dining rooms, the
Salon de Amours ("Lover's Lounge") has two
chairs and a couch, for maximum comfort.

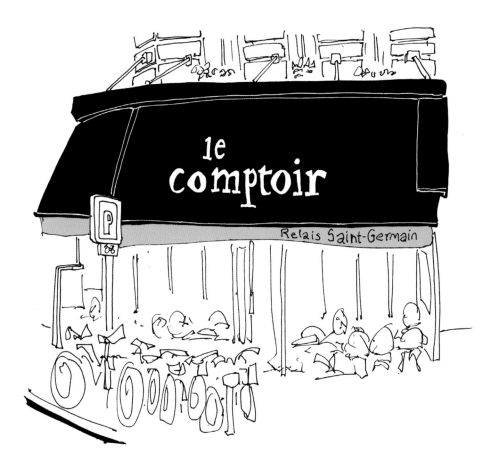

Le Comptoir (du Relais)

9 CARREFOUR DE L'ODÉON, 6TH ARR.

After Yves Camdeborde turned the idea of a bistro inside out at La Régalade in the 14th arrondissement during the 1990s, he took over this small seventeenth-century hotel to continue bringing good times and good value to the people.

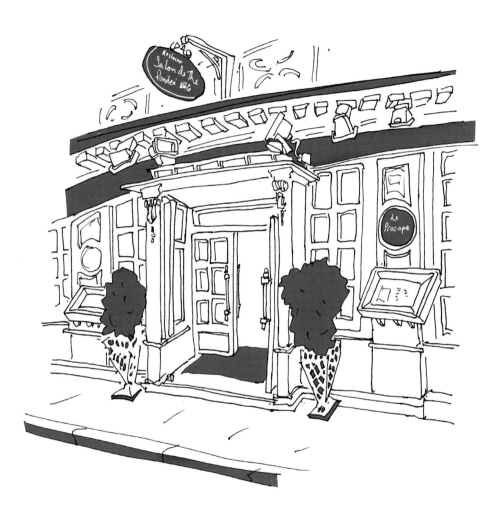

Le Procope

13 RUE DE L'ANCIENNE COMÉDIE, 6TH ARR.

The first coffeehouse in Paris. Robespierre, Marat, and Danton fomented the Revolution
here. We all know how that turned out.

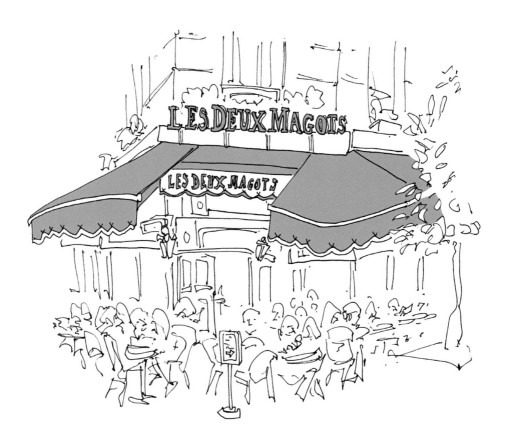

Les Deux Magots

6 PLACE SAINT-GERMAIN-DES-PRÈS, 6TH ARR.

This café has not only been name-checked in *Lolita* and was once a favorite of Bertolt Brecht, Albert Camus, James Joyce, Ernest Hemingway, and countless other writers, it even has its own literary prize, the Prix des Deux Magots, which has been awarded since 1933.

Jacquemart-André Museum

158 BOULEVARD HAUSSMANN, 8TH ARR.

A small gem, the home of dedicated art collectors of the nineteenth century. The excellent collection includes pieces by Botticelli, Frans Hals, Rembrandt, Tiepolo . . . on top of that, the walls of the main floor can all be lowered into the basement to make one huge room (suitable for balls).

Maison

3 RUE SAINT-HUBERT, 11TH ARR.

When Sota Atsumi (formerly of Clown Bar) and his wife, Akiko, opened their own place in the summer of 2019, it quickly became my new favorite restaurant. A serene space with gorgeous, Japanese-inflected French food. And at lunch, a true bargain.

★ Huîtrerie Régis

(SEE PAGE 93)

I never go to Paris without stopping in for a few oysters at this tiny boîte. Sometimes I go every day.

★ Pierre Herme

72 RUE BONAPARTE, 6TH ARR.

The man who turned pastry into fashion. I come just to look at the way the pastries are presented—more like jewels than something you're actually going to eat. But they are, of course, delicious.

Chantal in the Marché Paul Bert

110 RUE DES ROSIERS, 93400 SAINT-OUEN, FRANCE

Fantastic vintage clothing—much of it from the eighteenth century—at the flea market. Mostly too expensive to purchase, but these old couture clothes really are works of art. And sometimes there's something rather ragged that is affordable.

Other restaurants I love:

Chez L'Ami Jean

(SEE PAGE 106)

Pierre Gagnaire

(SEE PAGE 19)

★ Semilla

54 RUE DE SEINE, 6TH ARR.

Au Passage

(SEE PAGE 190)

—*Ruth Reichl,*
food writer and former editor of *Gourmet.*

6

From the Eiffel Tower to Les Invalides

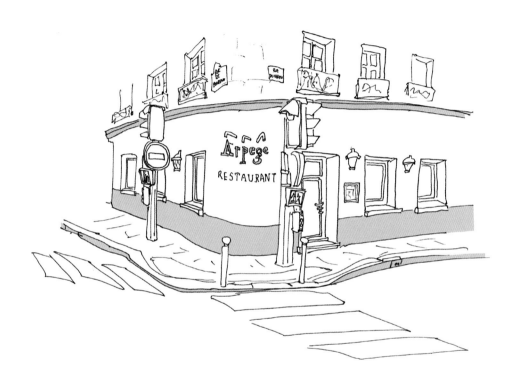

Arpège

84 RUE DE VARENNE, 7TH ARR.

Some say this is the best vegetarian restaurant in the world. There's little question it is among the most expensive.

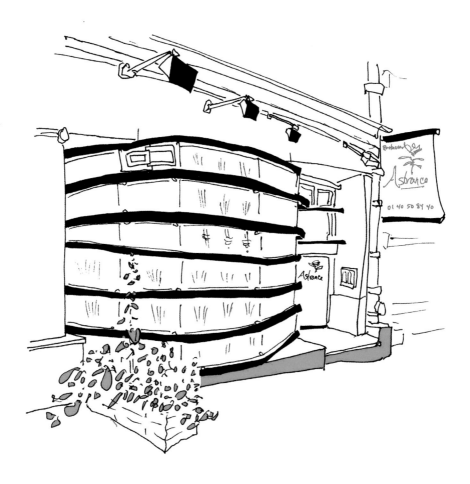

Astrance

4 rue Beethoven, 16th arr.

At the inimitable Pascal Barbot's flagship, there are no menus. You eat what he decides to serve you. Sometimes choice is overrated.

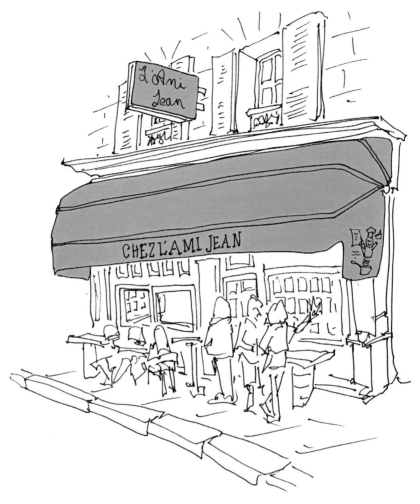

Chez L'Ami Jean

27 RUE MALAR, 7TH ARR.

The self-taught chef Stéphane Jego, a protégé of Yves Camdeborde during the heyday of La Régalade during the last century, took over this historic Basque rugby pub in 2003, and has been putting his own stamp on the future of bistronomie ever since.

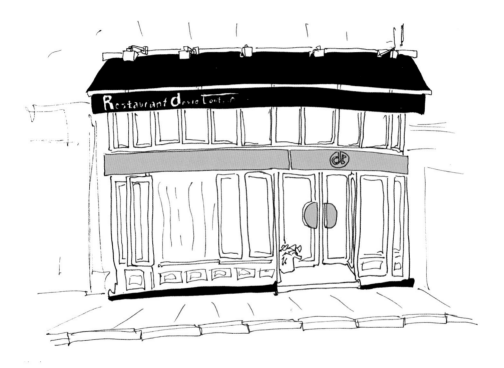

David Toutain

29 RUE SURCOUF, 7TH ARR.

The imaginative, two-star home of the progressive chef Toutain, who came up under the vegetable wizard Alain Passard at Arpège; the molecular gastronomy mastermind Marc Veyrat, in the Alps; and the culinary alchemist Andoni Aduriz, in Spain.

L'Atelier de Joël Robuchon

5 RUE DE MONTALEMBERT, 7TH ARR.

The workshop that spawned an empire.
Robuchon (1945-2018) had accumulated
more than thirty Michelin stars by the time
he retired, at age fifty, but he returned to
action here in 2003 with an intimate concept
that placed diners on stools and the chefs
front and center. There are now Ateliers on
multiple continents.

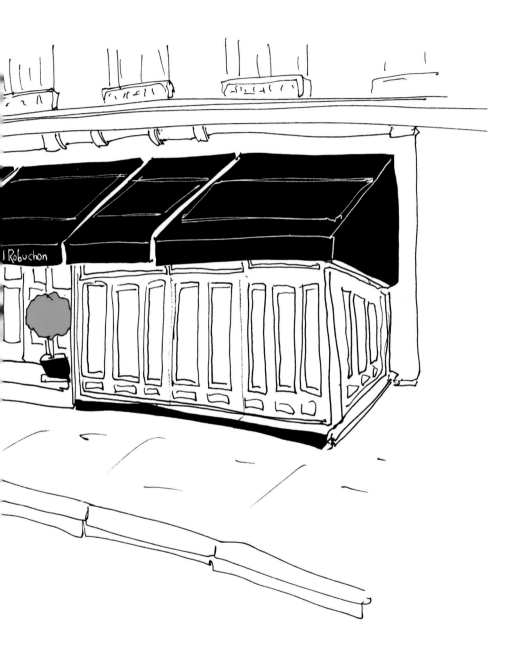

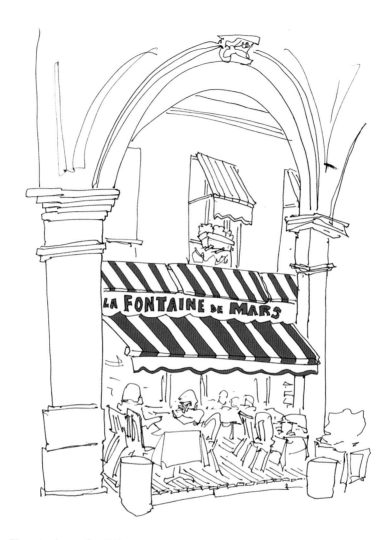

La Fontaine de Mars

129 RUE SAINT-DOMINIQUE, 7TH ARR.

Barack and Michelle Obama ate here when they visited Paris in 2009. They left the kids at home, but everyone is welcome at this charming bistro that's walking distance from the Eiffel Tower.

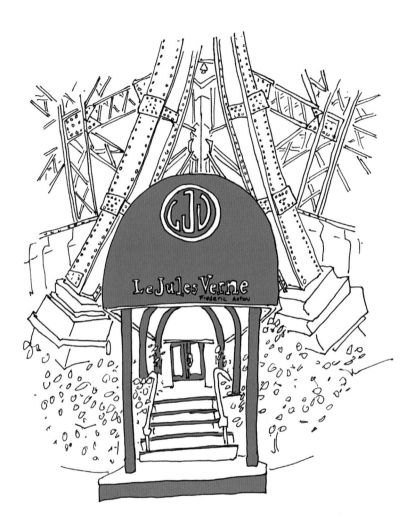

Le Jules Verne

AVENUE GUSTAVE EIFFEL, 7TH ARR.

In 2019, Frédéric Anton, who brought three stars to Pré Catelan, took over this storied restaurant on the second floor of the Eiffel Tower, 410 feet above ground.

Cartet

62 RUE DE MALTE, 11TH ARR.

I first read about this quirky bistro in
Mimi Sheraton's *1,000 Foods to Eat
Before You Die*; the owner, Dominique
Le Meur (who is also the chef, server,
sommelier, and dishwasher), is fond of
serving classical Lyonnaise dishes that
have all but disappeared elsewhere.
Sheraton suggested it as the place to find
boeuf à la ficelle, a strip of sirloin or fillet
that is tied, submerged, and poached
in an aromatic broth. However, there is
no set menu here, and Le Meur makes
whatever he pleases for dinner each
night—if you're interested in something
special, ask nicely when you make your
reservation (by phone, please; Cartet has
no website). When I brought my mother
here, the chef served us fresh bitter
greens, two elegant, Lyonnaise-style
terrines, boeuf bourguignon, and a buffet
of massive, family-style classic desserts:
crème caramel, *tarte aux citrons*, îles
flottantes, and a punch bowl full of bitter-
sweet chocolate mousse. From the street,
the tiny restaurant appears closed, but
fear not: A rap on the boarded windows
brings Le Meur to the door to welcome
you into his timeless dining room.

Baieta

5 RUE DE PONTOISE, 5TH ARR.

(SEE PAGE 67)

Julia Sedefdjian, the young niçoise chef
at Baieta, was only twenty-one years old
when she earned her first Michelin star.
Now twenty-five and running her own
Left Bank restaurant, she serves updated
interpretations of classic southern dishes
like "Bouillabaieta" (her dainty take on
bouillabaisse) and tender, red-wine-
braised beef cheeks. Both the menu and
the cheerful service are a welcome taste
of Provence in the midst of prim Paris.

★ Ducasse sur Seine

19 PORT DEBILLY, 16TH ARR.

Dinner cruises along the Seine are somewhat of a Paris travel cliché; architecture buffs appreciate the opportunity to encounter so many of the city's jewels from the unobstructed river vantage point. However, most of the large boat tours offer subpar food and crowded dining rooms at a premium. Instead, consider making a reservation for lunch on Michelin-starred chef Alain Ducasse's intimate Ducasse sur Seine. The day rate on this boat is a fraction of the evening price, and it allows diners to enjoy a more refined meal and the striking view by the light of day. Pro tip: These cruises also run on Sunday afternoons, when much of the city is closed.

—KAT CRADDOCK

is a writer and recipe developer based in New York City. She is the test kitchen director and food editor at *Saveur* magazine and has previously worked as a bread baker, pastry chef, and cheese buyer at restaurants throughout New York City, Boston, and Chicago.

I was in Paris in the summer of 2019, with my daughter and also with a broken ankle . . . and still (foolishly) walked the whole city to eat the most incredible things. My favorites by far were:

Mokonuts

5 RUE SAINT-BERNARD, 11TH ARR.

(SEE PAGE 202)

Everyone raves about the dessert. I loved the plump veal piccata on green beans, with tomato salad served warm. So homey and delicious.

Verjus

52 RUE DE RICHELIEU, 1ST ARR.

(SEE PAGE 127)

For the tasting menu: artichoke cream and flowers on a coronet! Socca taco with herbs!

Moonshiner

5 RUE SEDAINE, 11TH ARR.

Walk through the ordinary-looking pizza place for a dim speakeasy with perfect Negronis.

★ Cravan

17 RUE JEAN DE LA FONTAINE, 16TH ARR.

Most people love this place for drinks, but we loved it for a peaceful, neighborhood café with cappuccino, oats, and eggs.

La Cave de Belleville

51 RUE DE BELLEVILLE, 19TH ARR.

First you pass the cheese counter and wine shop, which is hard to do without stopping. Then you walk to the back to sit among the boxes of wine to have a mind-bendingly good cheese and charcuterie board to eat with a glass of natural wine

Circus Bakery

63 RUE GALANDE, 5TH ARR.

Fresh bread! Morning buns! All made all day long with organic flour, stone milled.

Fragments

76 RUE DES TOURNELLES, 3RD ARR.

I love breakfast in this little café, looking at the Bruce Lee poster and eating the open-face fruit tarts.

Joséphine Chez Dumonet

117 RUE DU CHERCHE-MIDI, 6TH ARR.

(SEE PAGE 166)

For classic classic French food, including duck confit and soufflé.

—*Dana Cowin*

is the founder of Speaking Broadly, a multimedia platform to democratize, spotlight, and nourish the voices of women. Before launching, Cowin was editor in chief of *Food & Wine* for more than twenty years. She's committed to helping fight hunger and increase job opportunities through her philanthropic work on the boards of Hot Bread Kitchen, Food Education Fund, and City Harvest.

7

LES HALLES
TO
PALAIS ROYAL

Au Pied de Cochon

6 RUE COQUILLIÈRE, 1ST ARR.

The summer my life turned upside down, I decided to go to Paris. In the throes of a divorce that revealed betrayals of the heart and financial deception, I was forced to leave the home where I'd lived for almost twenty years. Offers to teach in Paris that July led me and my eleven-year-old daughter, Annabelle, to rent a two-bedroom apartment in Montorgueil on a pedestrian cobblestone street. Annabelle, who we'd adopted from China, had been in school at a French lycée in Providence since she was three, and was nearly fluent that summer.

A friend asked David Lebovitz, an American living in Paris who is the author of, among other books, *The Sweet Life in Paris*, for restaurant suggestions for us. One of his recommendations was the onion soup at nearby Pied de Cochon. Pied de Cochon opened in 1947. Legend has it that there is no light switch or lock because it has never closed, staying open twenty-four hours a day for over seventy years. I was in need of comfort food and although, as the name suggests, pig rules here, it was that soup I was after.

How I longed for kindness that night, for something to make me feel hopeful and loved. But when we arrived at the restaurant, we were greeted brusquely, handed English menus, and unceremoniously led to a red banquette. Annabelle called to the maître d' in French, and speaking rapidly she asked for a French menu and a glass of rosé for me. The man's eyes widened. "Where is she from?" he asked me. "Where did she learn to speak French so . . . perfectly?" Before I could answer, Annabelle did.

As she spoke, the man's face brightened. "Her French," he sputtered, "it is *magnifique*." Soon, waiters buzzed around us, delivering whatever Annabelle asked for. The kitchen staff emerged to talk to her, and the chef personally delivered her onion soup, bubbling with browned Gruyère. Extras were brought to our table, tastes of this and that, all for the little Chinese girl who spoke perfect French. As we started to leave, Annabelle was presented with a box of meringues, shaped like pigs, to take home. Our cheeks were kissed. Annabelle bid them farewell, and we stepped out into the muggy Paris evening.

—ANN HOOD
is the author of the bestselling novels *The Knitting Circle*, *The Obituary Writer*, and *The Book That Matters Most*, as well as the memoir *Comfort: A Journey Through Grief* and, most recently, *Kitchen Yarns: Notes on Life, Love, and Food*.

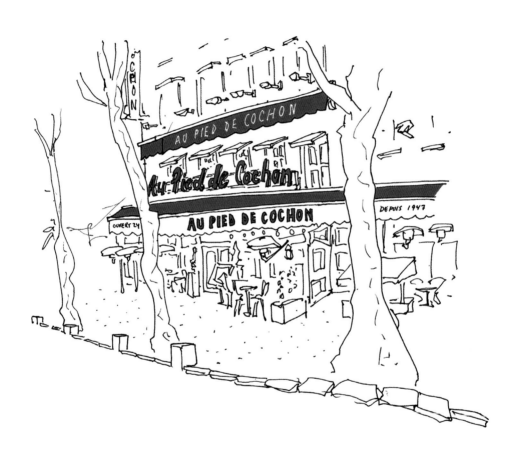

AU PIED DE COCHON

Au Pied de Cochon

AU PIED DE COCHON

DEPUIS 1947

ouvert 24

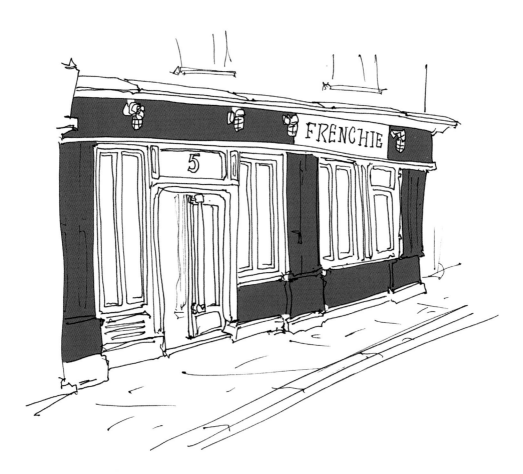

A lunch menu at Frenchie.

Frenchie

5 RUE DU NIL, 2ND ARR.

During a lunch meeting years ago in Manhattan with a woman named Sonja, I mentioned that I was heading to Paris. She said her friends were behind the hit restaurant Frenchie, which had recently opened and was getting a lot of attention for Gregory Marchand's inventive spins on French cuisine. The cozy spot on the rue du Nil was a real standout amid the blossoming bistronomie scene.

Sonja helped secure me a reservation—no easy task—and during my trip I dined solo at the small bar. The chef and his wife, Marie, both came by and introduced themselves. Marie, who was entertaining a few friends for most of the night at a nearby table, with some excellent wine bottles strewn across it, later casually mentioned that I should "treat Sonja well." I took it as a hint and, back in NYC, invited Sonja out for a proper date.

Fast-forward to early 2019, married and nine years into a relationship as well as parents of a girl and a boy, we returned to the expanded, renovated, and still-exquisite Frenchie to celebrate my fiftieth birthday. (Somehow, a grandparent had offered to mind the children while we traipsed off to Paris!) As I sat there next to my beautiful wife, the pleasant din of conversation and enticing aromas emanating from the now-more-open kitchen, I thought about how restaurants can play transformative roles in our lives. For me, for us, Frenchie is almost like a part of the family.

—RICHARD MARTIN,

a writer, editor, creative director, and producer based in Brooklyn, started going to Paris as a teen and continues to travel there as frequently as possible.

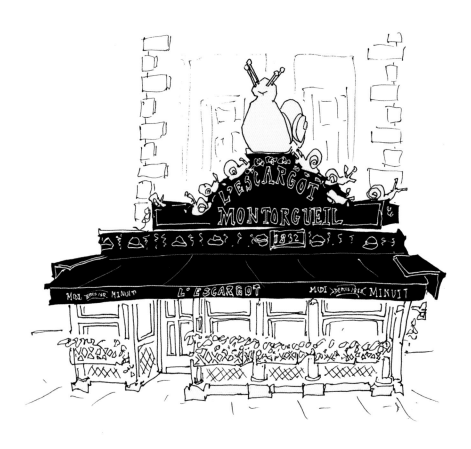

L'Escargot Montorgueil

38 RUE MONTORGUEIL, 1ST ARR.

Two centuries of escargot.

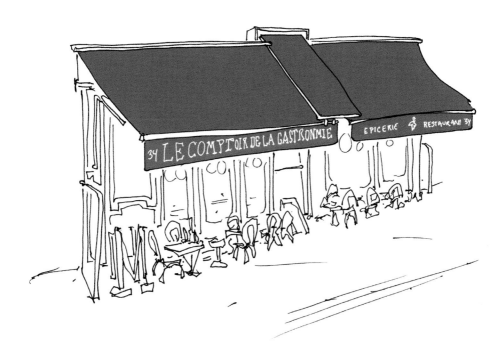

Le Comptoir de la Gastronomie

34 RUE MONTMARTRE, 1ST ARR.

Established in 1894, this is both a store and a restaurant. Either way, you can't go wrong with its homemade delicacies.

Le Grand Colbert

2 RUE VIVIENNE, 2ND ARR.

A bust of the namesake minister presides over the ornate dining room.

My husband and I always make a late-night pilgrimage to Le Grand Colbert each time we visit Paris. We like to go around 10 P.M., after the tourists have all gone home. We are surrounded by French couples and tables of other great admirers of the Belle Époque and able to soak in an atmosphere of vibrant colors and waiters who are attentive to every request. We always order the same dishes—Chateaubriand for two, pomme frites as only they can make them, and a great Cote du Rhône.

The first time we ate there, in 2014, we were very typical Americans trying to speak French to our nearest tablemates. I have a second college major in French and have taught French, so I do speak the language but not the way it is really spoken. The couple next to us were visiting from Brussels, where the husband was a chef. His wife cringed at my very American version of French and then softened and told me that her husband always insists they visit Le Grand Colbert after his Paris doctor's appointment. As most chefs do, he carried a little extra weight, and she said the doctor suggested he lose some. He said fine, but only after Le Grand Colbert.

—MARY KAY ABBLETT JASINSKI's grandfather grew up in Lille before leaving for America decades ago. The Indiana natve visits as often as she can to preserve the legacy of her family and pass along memories to younger generations, including her grandchildren.

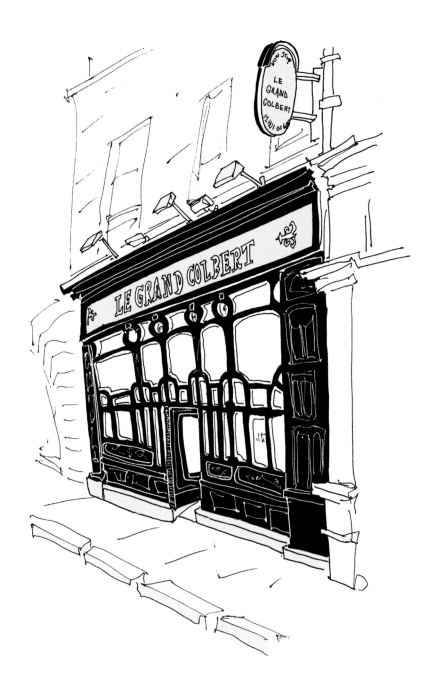

Le Grand Véfour

17 RUE DE BEAUJOLAIS, 1ST ARR.

Tucked in beside the gardens of the Palais-Royal, originally the home of Cardinal Richelieu, this is one of the oldest, finest, and most ornate restaurants in Paris.

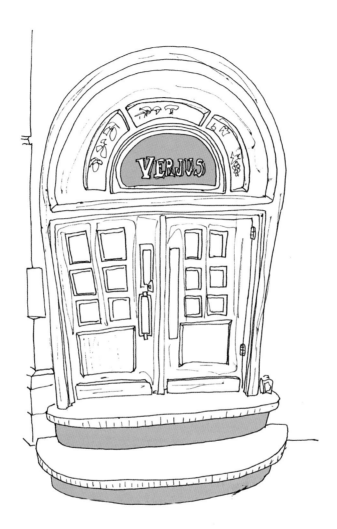

Verjus

52 RUE DE RICHELIEU, 1ST ARR.

Exceptional hospitality for a night you will never forget. If you can't get a proper table, the bar space down the outside staircase is serviced by the same kitchen.

Café de Flore

172 BOULEVARD SAINT-GERMAIN, 6TH ARR.

(SEE PAGE 90)

★ A la Civette

157 RUE SAINT-HONORÉ, 1ST ARR.

Maison Lemaire

59 AVENUE VICTOR HUGO, 16TH ARR.

Boutique 22

22 AVENUE VICTOR HUGO, 16TH ARR.

La Maison du Whisky

6 CARREFOUR DE L'ODÉON, 6TH ARR.

La Stresa

7 RUE CHAMBIGES, 8TH ARR.

Le Cherche Midi

22 RUE DU CHERCHE-MIDI, 6TH ARR.

Yen

22 RUE SAINT-BENOÎT, 6TH ARR.

Le Bon Marché

24 RUE DE SÈVRES, 7TH ARR.

I smoke cigars and have for sixty years. You can still smoke outside, at **Café de Flore**, for example. And so, in the afternoon or evening, you'll often find people, usually men but occasionally a woman, finishing their coffee and smoking a good cigar.

Cigar stores: **A la Civette** near the Palais-Royal is very reliable. **Maison Lemaire** and **Boutique 22** on the avenue Victor Hugo are as well.

Also, cigars are *relatively* less expensive in France, unlike London, where there is a steep tax on what is already not cheap. The **Maison du Whisky** at 6 carrefour d'Odeon has a good selection of gin as well as whisky, so if you're looking for Gin Mare or Sipsmith, that's the place to go. The first several times I went to Paris, I was working in London, so it was just a plane ride or train and boat trip away (before the Chunnel). And without much money on some of those trips, I'd "learn" the city on my feet. It is *the* great walking city. You just start out, turn a corner, then another, and find yourself where you haven't been before, which is just where you want to be.

A ★ means a suggestion is located in the current district.

I've been going to **La Stresa,** on the rue Chambiges, for thirty-five years or so. Italian food, very good, fresh. Run by the six Faioli brothers, maître d', waiters, kitchen. When they started up, Alain Delon and Jean-Paul Belmondo, who had offices nearby, used it as their canteen and brought all their friends. On the menu is pasta Alain Delon and pasta J-P Belmondo.

On the Left Bank I like **Le Cherche Midi** on the Cherche-Midi. Small, friendly, bustling, fresh food, nice wine, also Italian. **Yen,** a Japanese restaurant on the rue Saint-Benoit, is very good.

A couple of things to note: You can get as many bad meals in bad bistros in Paris as you'd get in the worst cities in America. And the French are just fine to get on with. Built into their culture is the greeting "Good morning, Good afternoon" before you ask for something. But it's good to learn "*Je ne parle pas bien Français. Est-ce vous parlez Anglais?*," rather than just buttonholing someone in the street and asking, "Which way is the **Bon Marché**?"

—*MICHAEL LINDSAY-HOGG* has directed for television, feature films, and Broadway, as well as doing videos for the Beatles, the Rolling Stones, the Who, and Elton John. He is the author of the memoir *Luck and Circumstance* and is currently at work on another. In 2019, he showed his drawings and paintings at the Galerie Pixi in Paris.

8

UP IN MONTMARTRE

Abri

92 RUE DU FAUBOURG POISSONNIÈRE, 10TH ARR.

Born outside of Tokyo and trained under Joël Robuchon, Katsuaki Okiyama opened this slim and deceptively simple-looking restaurant in 2012. The staff is Japanese, the menu out of this world, and reservations about as hard to come by as a trip to Mars. On Saturdays, he serves his take on the tonkatsu sandwich—a traditional Japanese pork cutlet.

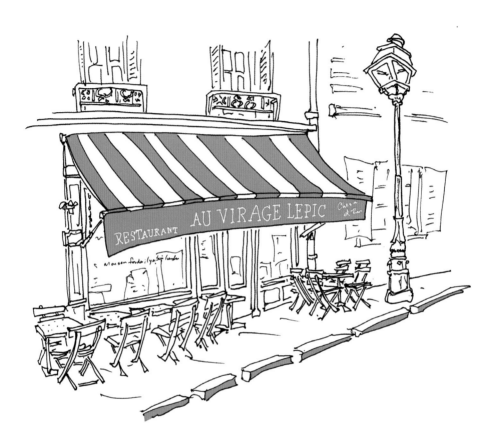

Au Virage Lepic

61 RUE LEPIC, 18TH ARR.

Homemade foie gras and cassoulet in the company of photos of American movie stars from the sixties and seventies.

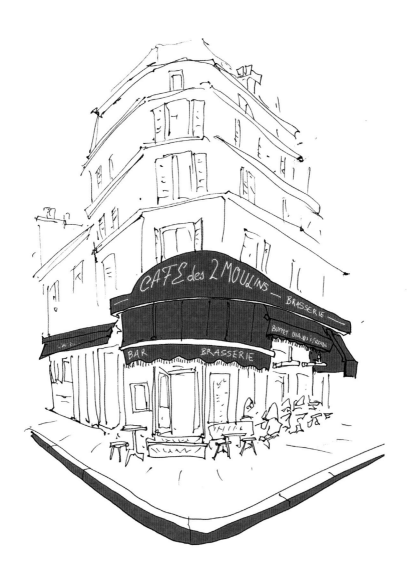

Café des Deux Moulins

15 RUE LEPIC, 18TH ARR.

The Montmartre favorite, made famous by the 2001 movie *Amélie*.

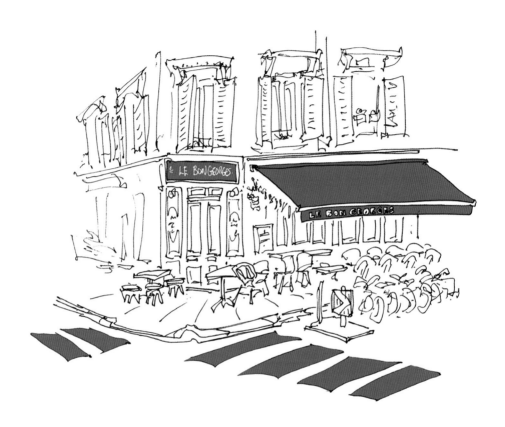

Le Bon Georges

45 RUE SAINT-GEORGES, 9TH ARR.

Since 2014, a favorite of local Parisians and far-off New Yorkers alike.

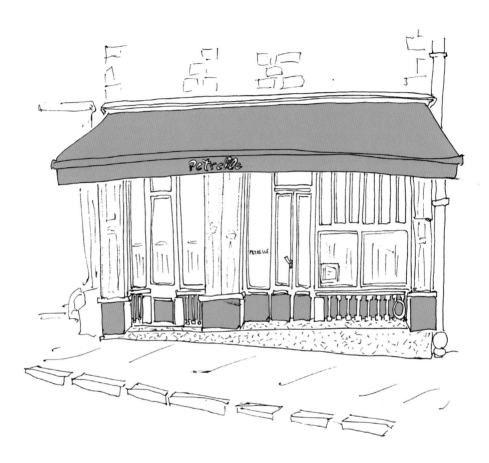

Le Petrelle

34 RUE PETRELLE, 9TH ARR.

My partner, an inveterate researcher, had compiled at least a meter-tall stack of references for a month's stay in Paris. We had been to Paris thirty-plus times before but always for just a few days at a time, which didn't allow us to roam far from our chosen hotel. This time, we rented an atelier in Montparnasse and were prepared to venture out.

We arrived early to Le Petrelle, on what had been described as a "quiet corner" of the 9th arrondissement. Quiet would be an understatement. There was nothing happening, not a café for a pre-dinner aperitif, nor a seat for waiting. And since our only available booking was the first of the evening, we were left to linger on the sidewalk as we waited. It was not a propitious beginning.

Yet as we entered, we knew that our wait had been worth it as we were met by parrot candlesticks coated in a cascade of wax, worn chartreuse walls stained by long-gone cigarette smoke, candles flickering, and crystal drops falling from dim bulbs. We were offered a corner table, next to drawings of books on the wall, a lighted hot pink and white translucent guitar in the corner, and an enormous oval mirror that allowed me to see my companion even when I wasn't actually looking at her.

Finding ourselves in a place so unmistakably French, we felt shy that our spoken grasp of the language was tourist-grade at best. Our waiter arrived promptly and I greeted him in my best-effort French. With a wide and wonderfully welcoming smile, he asked, "Where are you from?" in glamorously tinted English, the color of Paris on a warm fall evening.

The meal was exceptional, and classically French. Oddly, perhaps, I remember best a small salt pot attached to a carved dog; this "salty dog" lent a note of whimsy to our table. And another dog captured our hearts. As we prepared to leave, our waiter suggested we meet the chef. We expected to see Jean-Luc André, the culinary master who was also the one responsible for the electrifying décor. But as we rounded the corner from the dining room to the kitchen, a smallish dog, black face and ears with a white ring around his nose and a linen napkin wrapped kerchief-style around his neck, bounded out to meet us. The waiter smiled at our surprise, and as we praised the obliging pet, André himself came forward to say hello and ask after our meal.

—ROSEMARY KUROPAT
and her partner, Susan Slover, are retired owners of a New York City design and marketing firm that specialized in hospitality and retail. They have visited Paris more than thirty times.

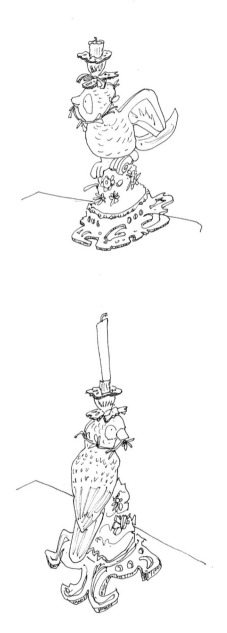

*The candlesticks are one of the more discreet
decorative elements at Le Petrelle.*

Le Refuge des Fondus

17 RUE DES TROIS FRÈRES, 18TH ARR.

Nothing but fondue and wine. Not even wineglasses—they use baby bottles instead (if you feel compelled to ask why, you may want to pass).

Le Wepler

14 PLACE DE CLICHY, 18TH ARR.

I was lucky enough to go to Paris with my mother and my husband. At that time, my husband was my boyfriend, and we had dated for only a couple of years, and this was the first big trip we ever did together. It was always just me and my mom for most of my life and now we were adding my boyfriend. This was the true test—can we survive a foreign land with foreign food without hating each other? Spoiler alert: Yes.

Le Wepler is the Paris restaurant of fantasies. Nearby is the famous Moulin Rouge. Not too far is Sacré-Coeur. The inside is like a Hollywood set—cozy red booths, cream-colored tablecloths, shining flatware, and lighting that can make you feel like you're in a romantic mystery novel. I remember walking in and feeling good. It's hard to describe, but there was a warm sensation that just felt good when entering the restaurant. Maybe it was the lighting? Maybe it was the custom plates with the "W" for Wepler? Maybe it was all the waiters dressed in the same uniform? Maybe it was everything together.

We had the onion soup to share. I didn't know onion soup could be so delicious. My mother had fish and I had steak. We always tried to get something different so that we could all share. It was wonderful. The best part of the night was our struggle to order. We attempted to do it in French, of course, but we failed miserably. The waiter insisted he give us the English menu, but we thought we could manage. We should have just looked at the English menu because my boyfriend didn't realize that he ordered the brain of a lamb. It looked like an actual brain, juicy, I should add. It was just a brain sitting elegantly on a porcelain plate. We all gave that look to each other—then we burst out laughing.

My mother passed away on Thanksgiving of 2019, and thinking of this meal reminds me of how much I miss her. Right when we sat down she looked at me and my now husband and said, "We are the luckiest people in the world because at this moment, we are together in this wonderful place about to eat like the royal family." At that time, I laughed. I thought she sounded crazy, but now it's something I want to relive over and over again.

—FRANCESCA BEERY
has been to Paris once but hopes to return there soon.

A view of the main room.

Diners at Le Wepler

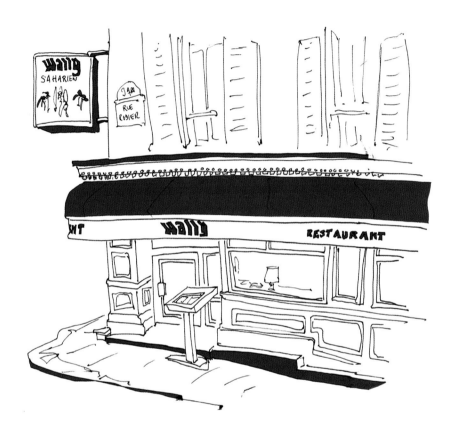

Wally Le Saharien

36 RUE RODIER, 9TH ARR.

Nearly fifty years ago, Wally Chouaki, a former camel driver from Algeria, introduced Parisians to ethereal couscous served as he had enjoyed it at home—dry, without broth or vegetables. Today, his student Djilla runs the kitchen in the same fashion, and the décor of carved chairs, elaborate carpets, and Saharian artifacts stands as a testament to his vision.

Sébastien Gaudard
22 RUE DES MARTYRS, 9TH ARR.

Popelini
44 RUE DES MARTYRS, 9TH ARR.

Fou de Pâtisserie
36 RUE DES MARTYRS, 9TH ARR.

La Meringaie
35 RUE DES MARTYRS, 9TH ARR.

A pub crawl, but for pastry: Start at the foot of the rue des Martyrs, stopping at **Sébastien Gaudard** (for the Paris-Brest), **Popelini** (choux à la crème, preferably dark chocolate), **Fou de Pâtisserie** (the pecan cookie from Karamel), and **La Meringaie** (pray it's winter, and you can have the Honorine). Destination Place Lino Ventura. You can sit on a bench, watch the merry-go-round whirl by, and tuck into your feast.

—*Lauren Collins,*
a *New Yorker* staff writer based in Paris and the author of *When in French: Love in a Second Language.*

★ Le Bon Georges
45 RUE SAINT-GEORGES, 9TH ARR.

(SEE PAGE 135)

La Scène
32 AVENUE MATIGNON, 8TH ARR.

Restaurant Pantagruel
24 RUE DU SENTIER, 2ND ARR.

Everyone needs a favorite restaurant they like so much they can go there without even thinking about it. For me, this means a place that's in my neighborhood, the 9th arrondissement in the heart of Paris, and one I can get to on foot. It must have very good food and a great wine list, of course, but almost as importantly, I want a restaurant where I know and like everyone who works there, the dining room is attractive and comfortable, and the atmosphere is friendly, unpretentious, and very Parisian. For me, the place that checks all of these boxes is **Le Bon Georges**.

It's been my local go-to table ever since it first opened in 2014, when I asked amiable owner Benoit Duval-Arnould why he spoke such good English. It turned out he'd once worked for the Campbell Soup

Company after it acquired a big French soup maker, but his dream was to climb out of those industrial-size soup vats and open a little restaurant with a chalkboard menu that showcased the best seasonal French produce.

That's what he did, and Le Bon Georges promptly became a hit in the quartier for a relaxed meal of highest-quality comfort food—maybe a steak from Polmard, a breeder of heirloom cattle in eastern France; cod sautéed with vegetables; or homey braised endives in béchamel sauce with ham. The wine list is spectacular, too, and the low-key literary chic of this place reminds me of what Saint-Germain-des-Prés was like when I lived there almost twenty years ago. Don't tell anyone else, but the 9th arrondissement, the aptly named Nouvelle Athenes, is the new Saint-Germain-des-Prés.

The most anxiety-inducing restaurant choice in Paris for most people is where to go for that big night out. You know, that elegant haute cuisine restaurant where you'll eat food you'll never forget and be pampered like royalty. Since most of the three-star places in Paris have become exorbitant, the place I'm sending people these days is Chef Stéphanie Le Quellec's **La Scène**, an intimate, elegant speakeasy-style supper club right in the heart of the city.

Le Quellec's cooking is intriguingly original but unfailingly delicious, as seen in dishes like poached langoustines with buckwheat and a blanc-manger quenelle of claw meat, veal sweetbreads with roasted cauliflower and harissa, and a ganache of Criollo chocolate from Venezuela made with olive oil. Charming service, too.

What's most rewarding about my work as a Paris food writer and restaurant critic is the gastronomic elation of discovering a spectacular new restaurant, chef, or food producer. One of my latest finds is **Pantagruel**, Chef Jason Gouzy's small, simple contemporary French restaurant in the Sentier, Paris's old garment district. Gouzy's cooking is poignantly earnest, powerfully precise, and lyrically creative, as exhibited by dishes like smoked parsnip with trout roe and turmeric emulsion and beef cheek with squid's ink and red wine sauce. Gouzy doubtless has an illustrious future in front of him.

—*Alexander F. Lobrano*
is a food and travel writer who has lived in Paris since 1986. His latest book is *My Place at the Table: A Recipe for a Delicious Life in Paris* (2021, Houghton Mifflin Harcourt), and he contributes regularly to the *New York Times*, *Wall Street Journal*, and many other publications.

★ Café Tabac

1 B RUE RAVIGNAN, 18TH ARR.

★ Neo. T.

89 RUE DES MARTYRS, 18TH ARR.

★ Muse Montmartre

4 RUE BURQ, 18TH ARR.

★ Le Carillon de L'Olivier

34 RUE ABBESSES 18TH ARR.

★ L'Épicerie des Environs

18 RUE RAMEY, 18TH ARR.

Day by Day

46 RUE DES MOINES, 17TH ARR.

Belle Maison

4 RUE DE NAVARIN, 9TH ARR.

Terminus du Nord

23 RUE DE DUNKERQUE 10TH ARR.

Café Chilango

82 RUE DE LA FOLIE MÉRICOURT, 11TH ARR.

Soya Cantine

20 RUE DE LA PIERRE LEVÉE 11TH ARR.

Bistrot Paul Bert

22 RUE PAUL BERT, 11TH ARR.

(SEE PAGE 000)

La Cantine de Merci

111 BOULEVARD BEAUMARCHAIS, 3RD ARR.

I'm a big fan of getting off the beaten track and just walking walking walking. But even after serving as my home for more than twenty years, Paris never fails to delight, inspire, and offer new hidden corners of pleasure.

I have lived in Montmartre since almost the start of my love affair with Paris. My favorite thing to do is head out for an early morning or evening walk to enjoy my neighborhood with fewer people around.

Some of my favorites are a foamy cappuccino at **Café Tabac**, organic bulk tea on the rue des Martyrs at **Neo. T.**, and gorgeous flowers at **Muse Montmartre** with Majid, a flower genius. I always head to **Le Carillon de L'Olivier** for organic supplies and produce—a tiny shop that has it all, **L'Épicerie des Environs** for local produce and products, and **Day by Day** for all my bulk needs. I love to have a relaxed, and delicious, meal of seafood at **Belle Maison** and to walk to Gare du Nord for bistro food in authentic ambiance at the **Terminus du Nord**.

I often hop over to the 11th and the neighborhoods behind République and down from Goncourt and Parmentier. Some favorite foodie spots are the tiny Mexican **Café Chilango**, vegan lunch at **Soya Cantine**, classic French lunch or dinner, with ambiance, at **Bistrot Paul Bert** (their fries, pepper sauce, and profiteroles . . . !) or to push farther toward Bastille for vegetarian at **La Cantine de Merci**.

I also adore discovering all of the hidden corners of Paris and a few off-the-radar neighborhoods: the African neighborhood La Goutte D'Or, and eclectic foods from different cultures in Ménilmontant and the Canal de L'Ourcq.

—ERICA BERMAN,
the founder of the popular blog *HiP Paris*, recently sold Haven In, her successful vacation rental company, and in 2019 launched Veggies to Table, a nonprofit to feed the food-insecure in Maine, where she lives now.

9

NEAR
PLACE DE L'OPÉRA

Astair

As is often the case with our group, we were running late as we quickly made our way down the perfectly Parisian cobblestone alley. We entered Astair with anticipation and hunger—after finishing a four-and-a-half-hour motorized bike tour of Paris in the rain, some of us were just happy to be alive. We are seven best friends who met thirty-plus years ago attending elementary school in Los Alamos, New Mexico. We forged a link in "the little atomic city" over soccer tournaments, sleepovers, and shaving-cream fights. Our friendship has blossomed into a sisterly bond, adorned with unconditional love and admiration for each other. We are wives, mothers, doctors, CEOs, world explorers. Through it all we held each other's hands, always reminding ourselves, while we may not have it all together, together we had it all.

We settled into our seats, and quickly ordered champagne and two bottles of wine. Our waitress, Clara, smiled and poured the first round as we settled in, laughing. Clara guided our Paris food journey while also ensuring they accommodated those in our group with gluten and fish allergies. With a great sense of humor, Clara and another server assisted us in eating escargot. It takes a little skill and all I could think about was that scene in *Pretty Woman* where the snail flies across the room. I can guarantee without Clara's help that would have happened to me. As some of us were celebrating our fortieth birthdays, the servers serenaded us (in English), lit candles, and once again made us feel completely spoiled.

It was one of those meals that makes it feel like time stands still. In America, meals are often hurried affairs. This was a rare occasion for most of us where we could savor every moment and every bite. It was nourishment for the soul as much as the body. To sit with childhood friends in Paris and share food, champagne, stories, laughter, and tears was an incredible gift.

—THE "ATOMIC SISTERS" (TINA CHAVEZ, JESSICA HALL, RAMONA JOHNS, CHRISTINA KRAEMER, MICHELLE LONGMIRE, HANNAH SANDERS, TRACY STALLINGS).

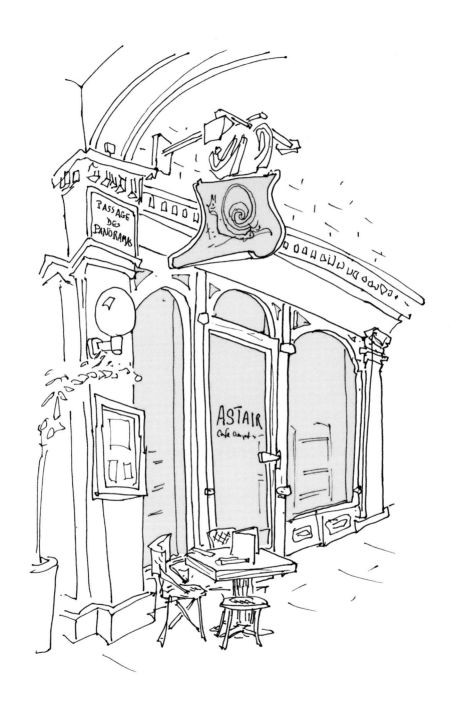

PASSAGE DES PANORAMAS

ASTAIR
Café Aupol

151

The stylish and mod bar at Astair.

A taxidermied zebra guards the kitchen doors at Astair.

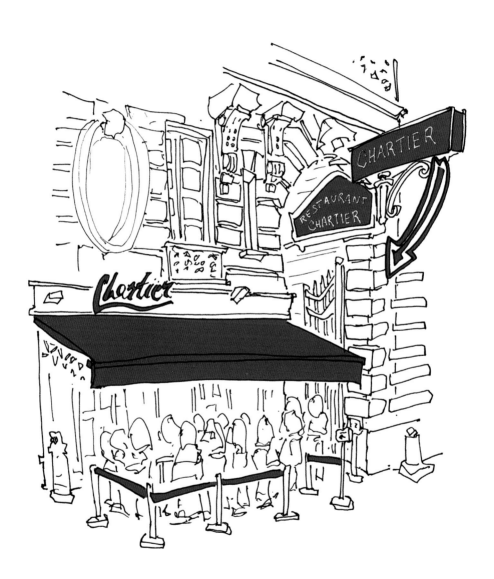

Bouillon Chartier

7 RUE DU FAUBOURG MONTMARTRE, 9TH ARR.

I can't help but smile when I think of my visit to Bouillon Chartier. It was my boyfriend Jonathan's birthday, which fell on Sunday, our last night in Paris. We opened the door at 9 P.M. and were quickly immersed in the warmth and excitement of about a hundred people chatting in French, laughing, and clinking silverware—a stark contrast to the quiet atmosphere outside.

Despite the fact that the restaurant was packed, we were seated within moments of entering the door at a table with, it seemed, the only four unclaimed chairs in the entire restaurant. The menu was simple and surprisingly inexpensive. Our server took our order quickly, and with a smile. Another couple joined us at our table, which is the custom here. We knew enough from our research on Parisians not to try to strike up conversation, which was fine with us.

During our meal, the entire restaurant broke out into song, laughter, cheers, and general merriment each of the three times that the servers produced birthday treats with sparklers for guests. The humble guy he is, Jonathan declined my offer to mention that it was his birthday as well, which is my only regret regarding this whole experience. We spent most of the meal taking in the cheerful tableaus surrounding us, gazing at the restaurant's gorgeous art nouveau interior, and enjoying each other's company.

—ASHLEY KNOBELOCH,
community health nurse from Madison, Wisconsin. First-time visitor to Paris to celebrate her parents' fiftieth wedding anniversary with them.

Café de la Paix

5 PLACE DE L'OPÉRA, 9TH ARR.

Until Charles Garnier completed his elaborate auditorium in 1875, the Café de la Paix, which opened thirteen years earlier, was all dressed up with no place to go. Now it's an anchor on the bustling place de l'Opéra, and in between was favored by the likes of Sergei Diaghilev, Émile Zola, and Guy de Maupassant.

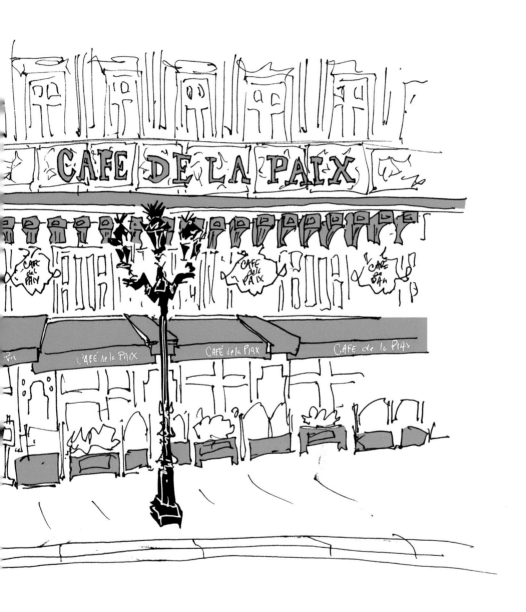

Chez Georges

1 RUE DU MAIL, 2ND ARR.

Since 1964, the most Parisian of Parisian restaurants, and reportedly where Julia Child had a life-changing encounter with sole meunière.

Drouant

18 RUE GAILLON, 2ND ARR.

Long the home of France's most prestigious literary prize, the Prix Goncourt. Pro tip: Drouant often offers a modest and relatively affordable prix fixe option nightly.

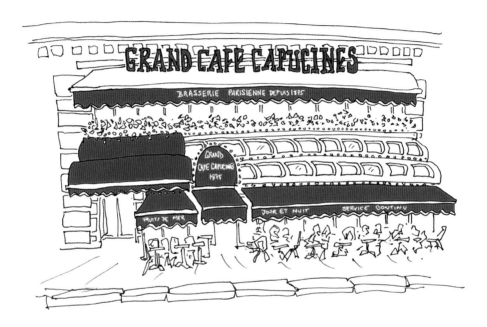

Le Grand Café Capucines

4 BOULEVARD DES CAPUCINES, 9TH ARR.

The first commercial screening of a film took place here in 1875, ten years after its opening, when the Lumière brothers set up shop for a slate of ten shorts. It was extensively renovated in 2019 and now is as polished as a movie set.

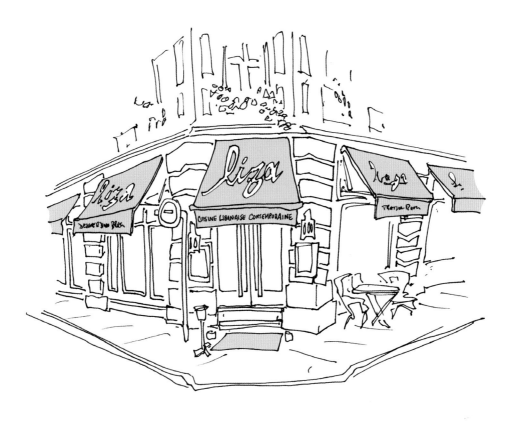

Liza

14 RUE DE LA BANQUE, 2ND ARR.

Liza Soughayar and Ziad Asseily's showstopping take on the cuisine of their native Lebanon.

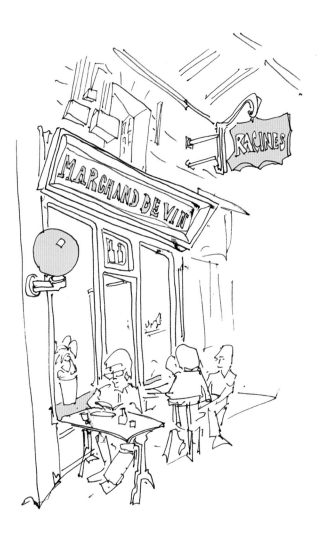

Racines

8 Passage des Panoramas, 2nd arr.

Inside the captivating Passage des Panoramas, a covered passageway typical of nineteenth-century Paris, the Sardinian chef Simone Tondo serves a market-driven menu inspired by the food of his native country. The wines are Italian, too, and if you're looking for a superlative tiramisu, look no further.

★ Chez Georges

1 RUE DU MAIL, 2ND ARR.

(SEE PAGE 158)

I am a sucker for the old-school, this-is-how-it-was French bistro. The waitress is a tad prickly but very efficient. The décor is perfect—red banquettes, white tablecloths, tables a bit too close, big napkins, big silverware, but no fuss. Once, after a bad dream, I had a pink paté for lunch that dispelled all the gloom. A woman with a giant bow on her head was applying lipstick while her dog looked on. The people were real. I felt real. And fortified to continue on my way.

Luxembourg Gardens

6TH ARR.

There are two parks that fill my heart. They are both in the middle of stupendous cities. Central Park in New York and the Luxembourg Gardens in Paris. When I am in Paris, I go there every day. There is an outdoor café to have a coffee and draw. There are benches and chairs for a ham/cheese baguette. Trees. More trees. There are dogs. Children. Nannies. Parents. Elderly. All elegant and sure. All exuding a pervasive self-confidence that is particular to Paris. And also, it is steps away from the buildings, museums, shops, and streets that I adore. What more could you want?

—MAIRA KALMAN,
author/illustrator.

A ★ means a suggestion is located in the current district.

10

Montparnasse and Adjacent

Joséphine Chez Dumonet

117 RUE DU CHERCHE-MIDI, 6TH ARR.

I've been here three or four times and loved every visit. It's a comfortably old-school bistro. There's a big brandy snifter in front that's filled with eggs and truffles. My favorite meal is a rocket salad with truffles, tournedos Rossini, and a tarte Tatin. I was celebrating my birthday one year with a bunch of chefs and we went down into the wine cellar, where you had to step over Kermit dolls and kids toys to reach the ancient bottles of Petrus going back to 1904.

—PETER KAMINSKY is the former underground gourmet for *New York* magazine and a longtime outdoors columnist for the *New York Times*. His seventeen cookbooks include collaborations with Gray Kunz, Sheila Lukins, Daniel Boulud, Michel Richard, Francis Mallmann, and, most recently, Ned Baldwin (*How to Dress an Egg*).

ANOTHER KAMINSKY RECOMMENDATION

La Maison de la Mouche

1 BOULEVARD HENRI IV, 4TH ARR.

There's a nice old fishing-tackle store on the Île Saint-Louis by the bridge leading to the Institut du Monde Arabe. It's very simple but full of good stuff. I remember they had a nice map that shows where you can fly fish in France. They once let me take a rod down to the Seine, where I tried a few casts against the background of Notre-Dame.

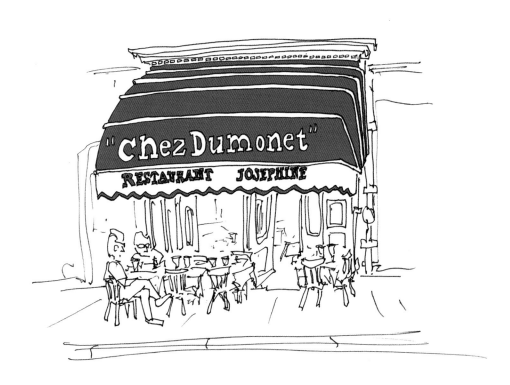

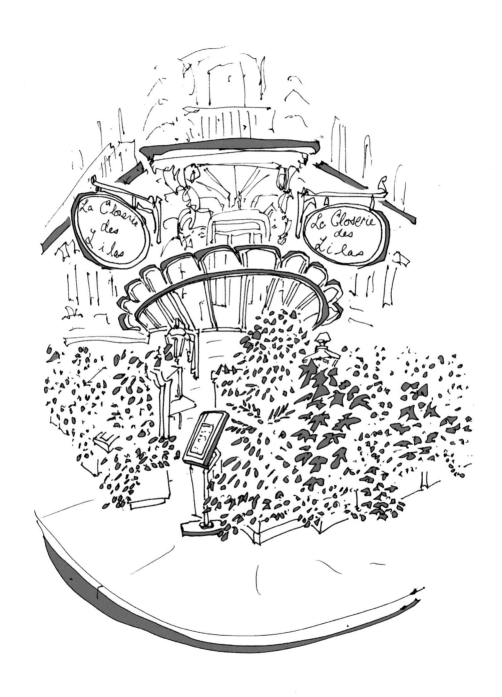

La Closerie des Lilas

171 BOULEVARD DU MONTPARNASSE, 6TH ARR.

La Closerie des Lilas opened in 1847, and Ernest Hemingway came here all the time. F. Scott Fitzgerald handed him the manuscript to *The Great Gatsby* at the bar. As I sit outside at a table sipping Sancerre while on an extended holiday, I imagine I'm enjoying my wine with Hemingway's ghost and we are talking about life and how to live it properly and describing it in run-on sentences and talking horse racing, which I am well versed in since my childhood days hanging out at Santa Anita with my father, who often spent his paychecks at the track.

The Sancerre is kicking in a bit and it feels nice and good. The sun has finally come out after four days of gray skies and I'm taking in the clear blue day. It is a nice feeling and I plan to seek it out more often in all the things I do. Not necessarily the Sancerre part, but the feeling part.

I live in LA and work in the film business, which is known to insiders as Hollyweird. It's a town where the people are hard and fast and want to get to places very quickly, and if you're not one to help them get where they want to go, well, then café time won't be as long as it is here in Paris. Hollyweird is a tough place to make good friends for friendship's sake. And it's short on human decency. Friendships are often forged to make you famous or rich. Or at least feel good about yourself.

Mr. Hemingway tells me, "Three months in Paris? Take the time to enjoy this fine city and discover and be present and mindful. Fall into whatever cracks and crevices happen in front of you. Then see how it changes your work."

I say, "*Oui, mon ami,*" and we toast. Then I laugh. How could Hemingway afford to write and hang out at La Closerie des Lilas? A steak costs sixty bucks and a half bottle of Sancerre costs twenty-five bucks. Oh, Hem. Still, I order the Assiette gourmande Closerie des Lilas, for dessert. Life is too short not to eat dessert—especially this amazing French dessert.

—VINCE DUQUE,
a first assistant director in Los Angeles for the FX comedy *Dave*, spent three months in Paris in 2016.

S. DE BEAUVOIR JP SARTE

Their existential crises long over, Simone de Beauvoir and Jean-Paul Sartre's seats remain, at least according to the plaque on the table.

The plaque says "This is where Papa sat."

The bar room.

La Coupole

102 BOULEVARD DU MONTPARNASSE, 14TH ARR.

As a high school junior in 1963, I scored the highest on an American history exam and won a trip to Europe. I joined a dozen or so tourists on a package tour visiting a new place every day or two for a month. On our evening off in Paris, we all went to La Coupole.

Having had one year of high school French preceded by two years of Latin, I was the linguist of the group (tour guide included). My trilingualism notwithstanding, as tourists we received the English-added menu. The guy next to me went conservative, ordering "American Steak." Having just seen the movie *Taras Bulba*, I was a bit romantically deluded on Tartar cooking. I ordered "Tartar steak," thinking the rustic Tartars must have had a good recipe.

After a short time, the waiter presented the guy next to me with a nice steak with a sunny-side-up fried egg on top. The tourist was nonplussed. "This must be yours," he said as he removed the plate to my position. The waiter moved it back and gave me mine.

I was presented with a mound of raw hamburger with a raw egg cupped in its center, surrounded by such things as chopped hard-boiled egg, what must have been capers, raw onions, and so on. Since I was paying for it, and it was on the menu, I was going to have to eat it. Which I did, except for the raw onions. My new rule was "If it's on the menu, it's edible. Except raw onions." It has served me well so far.

—LEWIS LEBETKIN
is a retired physician living on Long Island. He will eat anything that doesn't contain infectious diseases.

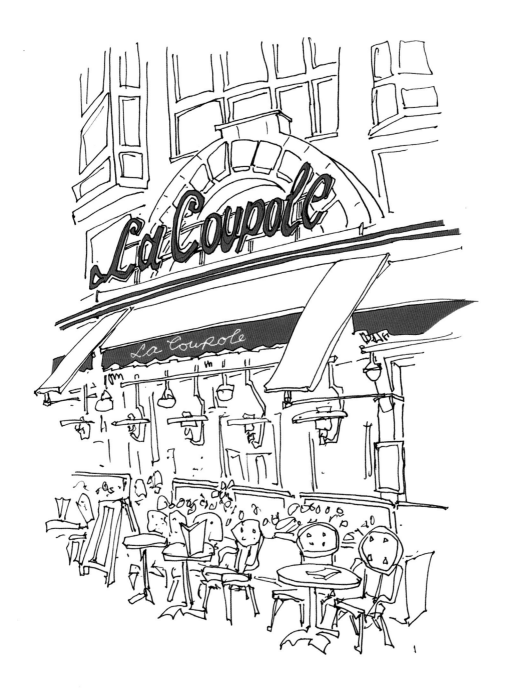

A century ago, James Joyce drank whisky at La Coupole's "Bar Américain."

The well-connected cubist Marie Vassilieff's work adorns a column on the back wall (the restaurant hands out a map of the rest of the works by such artists as Henri Matisse and Fernand Léger that still remain).

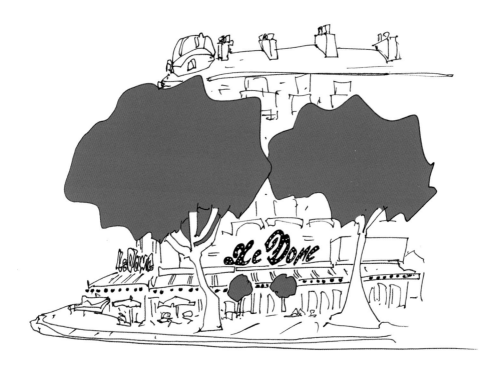

Le Dome

108 BOULEVARD DU MONTPARNASSE, 14TH ARR.

I went to Le Dome with my boyfriend to celebrate our fifth anniversary. Its ancient furniture, velour chairs, and old pictures on the walls immediately transported us to the Paris of old times, but what was absolutely remarkable was the service.

My boyfriend ordered a starter and when it arrived I was craving it, too. We started to share it from one plate. When a waiter—a young guy—asked about bringing us a second plate, we refused. Not wanting to bother anyone, we said we were OK.

A senior waiter, who had been working in Le Dome for many years, heard the conversation and came to us immediately with a second plate. He pushed the young waiter aside and started to split the dish into two for us. He was giving a lesson to the young boy and entertaining us at the same time, but there was not even a drop of arrogance or humiliation in his action. He displayed his best to us and to the young waiter, who was learning from the best. It was so interesting to observe so much passion. It was quite a show! When we thanked the senior waiter, he explained everything. "You must love what you do," he said. "Otherwise there is no point to do it at all."

—*Natasha Gri,*

who was born in Latvia and lives in London, first set foot in Paris at age eighteen. For the past few decades, she's visited the city two to three times a year.

The interior of Le Dome.

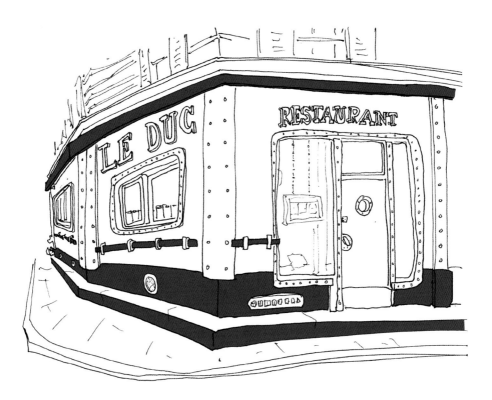

Le Duc

243 BOULEVARD RASPAIL, 14TH ARR.

When I think of Le Duc, I can still taste the buttery langoustine in my mouth. In the end, we made jokes that if we were eating this at home, we would lick the rich orange emulsion off the plate. I was there for lunch with Vincent, a brother of the owners of this famed seafood restaurant. Vincent and I are friends from New York. Amazingly talented at cutting hair, he's been doing my hair for the past five years. I would go to Le Bernardin in New York with my parents and send him pictures. He would say, you have to go to Le Duc in Paris.

I flew in from NYC and, after a quick shower at a friend's place in the 6th, I went straight to our 1 P.M. reservation. I was wearing a midnight blue Balmain mini-dress with gold buttons that glinted in the midday silvery autumn sun as my high heels clicked out of the Paris taxi onto the sidewalk. I walked in to find a tiny jewel box bar with warm brown leather stools opening out onto a small bright room with a distinct nautical theme. Its uniquely minimalistic timeless Parisian vibrations gave me the feeling of stepping into an original sophisticated archetype.

Vincent was waiting for me in the kitchen with his brother and a few waiters. He came out laughing and smiling, very at home at his family's restaurant. His taller brother told us to sit in the cozy bar table in the corner. Only two other tables were occupied. At one, there was an old French man with a very tall young girlfriend, day drinking red wine on a boozy springtime/autumn date. At the other sat an eccentric countess in a black velvet cape and her young date.

We sipped a cold white while Vincent and his brother just nodded and made our orders appear. Quickly, from the quiet kitchen, all of the famous fish dishes in the form of small plates arrived at our table, including those langoustines. The prawns' abiding flavor made me wonder what these brothers eat at home and where this amazing sensibility came from. It must be from their father, no doubt, who founded this restaurant in 1967. The dedication to his craft still shines more than five decades later.

—LAUREN RUICCI,

a jewelry designer whose company is Laruicci, started going to Paris to show her collection at the trade shows twice a year, but more recently has started visiting Paris every month.

A fittingly nautical décor distinguishes the timeless interior.

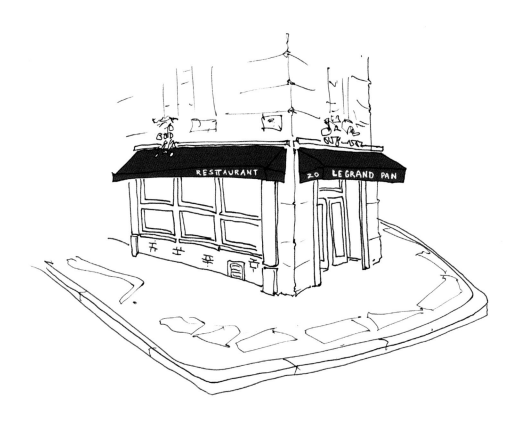

Le Grand Pan

20 RUE ROSENWALD, 15TH ARR.

This tidy bistro may be a bit out of the way, but it's a favorite of actresses Catherine Deneuve and Juliette Binoche, so it must be doing something right.

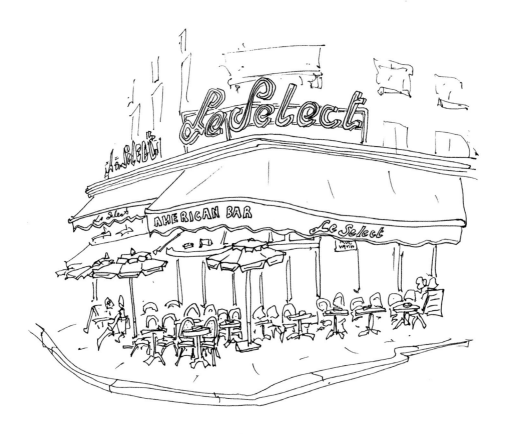

Le Select

99 Boulevard du Montparnasse, 6th arr.

The spirit of the 1920s hangs in the air at this famed literary hangout. Communing with the Lost Generation is but a cocktail away.

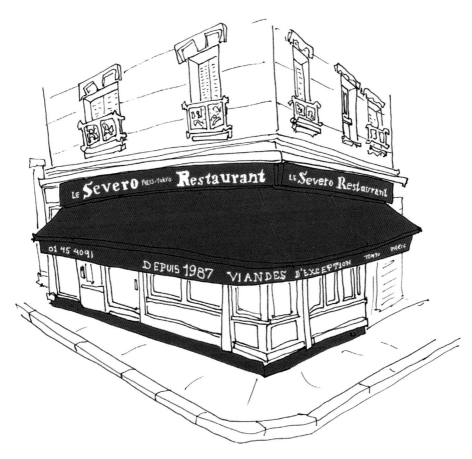

Le Severo

8 RUE DES PLANTES, 14TH ARR.

It's tiny and out of the way, but worth it. For three decades, William Bernet, a former butcher, has served what many regard as the best steak in Paris.

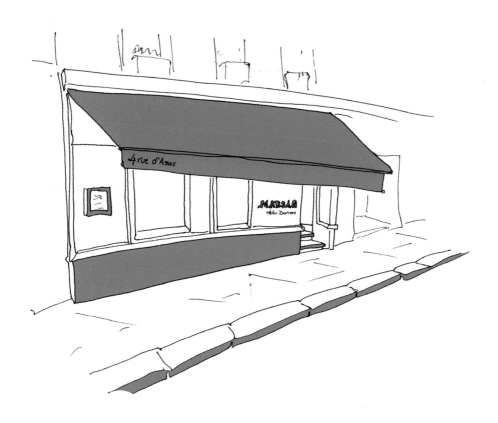

Marsan par Hélène Darroze

4 RUE D'ASSAS, 6TH ARR.

Two decades ago, Darroze, who was voted the World's Best Female Chef in 2015, opened her flagship restaurant on the Left Bank. In 2019 she reinvented it, taking inspiration from the commune in Southwest France where she was raised. "I am Basque-Landes. I am made from that family and that soil; they are the origin of everything I am," she has said. "As I mature, I find myself going back."

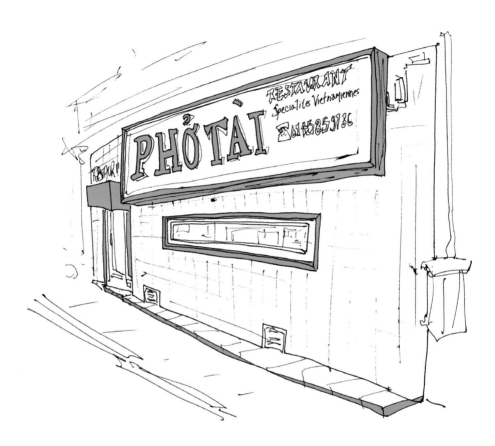

Pho Tai

13 RUE PHILIBERT LUCOT, 13TH ARR.

Te Ve Pin left Vietnam in 1968 for cooking school. He has done so well here in the years since, he and his family have opened a sister restaurant, Pho Tai Tai, across the street for spillover.

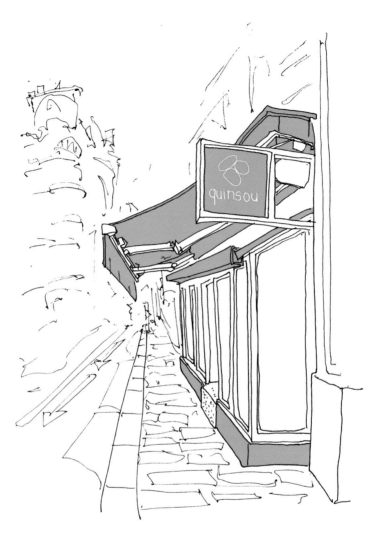

Quinsou

33 RUE DE L'ABBÉ GRÉGOIRE, 6TH ARR.

When a place is recommended by the staff at both Clown Bar and Verjus, don't ask questions, just go.

11

BETWEEN REPUBLIC AND BASTILLE

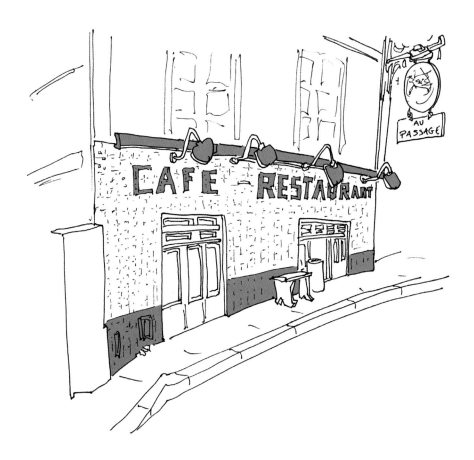

Au Passage

1 BIS PASSAGE SAINT-SÉBASTIEN, 11TH ARR.

Small plates and late nights.

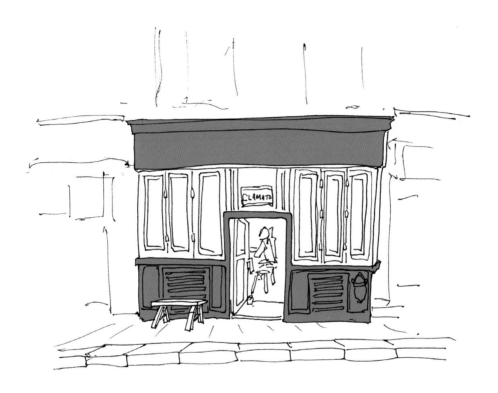

Clamato

80 RUE DE CHARONNE, 11TH ARR.

Next to its esteemed sister restaurant Septime, this understated seafood restaurant doesn't take reservations, but its small, shareable plates are so exceptional that it's worth showing up at the unfashionably early hour of 7 P.M. for a seat.

Clown Bar

114 RUE AMELOT, 11TH ARR.

It was my first night in Paris. I was with my girlfriend, who had been dying to visit the city for a long time. We were supposed to end up at a renowned restaurant in the Marais for dinner, but upon many suggestions from friends to visit Clown Bar, we decided to hop in for a glass of wine beforehand. When we walked in, it was like being in an amusement park. Not only for the decorative and amusing clown art lining the wall—the atmosphere and wine list were meant for adults to let loose and enjoy themselves.

We sat at a high top and were approached by the bartender, Renaud. I already knew what I wanted to drink. I saw a man sitting by himself at the bar with a bottle of wine. A glass was poured in front of him. The color was the most perfect red—slightly hazy, bright, yet deep. I asked Renaud for whatever he was having. Chuckling and most friendly, he said, "Unfortunately I don't have any more. It's highly allocated and made by a small natural producer in Auvergne." Seeing my disappointment, he told us he'd return in a moment.

He went over to the man at the bar and spoke a few words in French. When he returned, he told us the man at the bar would give us the rest of his bottle if we were OK that he'd already had a glass. I had never encountered such generosity, especially among strangers while in another country. I immediately said yes and thanked the man. He soon left the bar, but we remained drinking the best wine I've ever had and continuing to share a few moments with Renaud. We decided to hang there all night and take all of Renaud's suggestions on food and wine (both of which were unbelievable). As we left, he said, "You must go to Goguette down the street tomorrow."

So the next night, after some sightseeing followed by an incredible meal at Au Passage (escargot in herb butter, perfectly roasted endives, and scallops with asparagus) just a couple blocks away from Goguette, we strolled over and sat outside for a nightcap, which happened to be a bottle of hazy and energetic rosé made by Marie and Vincent Tricot. We were sitting outside when Renaud strolled by.

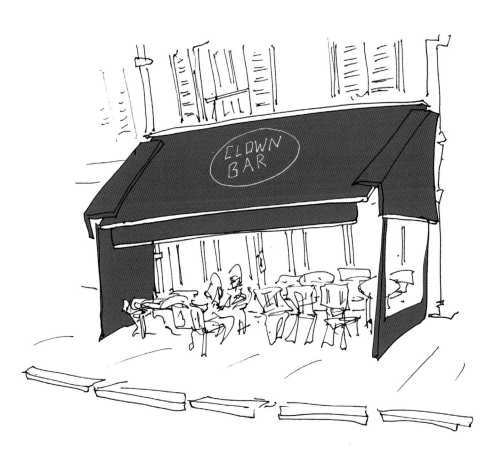

There are clown mosaics on the wall, and the cutlery is tucked away in a drawer beneath each table.

We offered him a glass of our wine and he sat with us. We chatted and caught up on the day's events. As it got later and the restaurant was closing, he said, "Come inside, I'll introduce you to my friends here." We had no idea what to expect. We were thrust into the most lively and friendly gathering of industry folks— where friends poured each other wine freely, shared stories, and danced to Spice Girls. At one point, someone even pulled out a flute and played various national anthems to everyone's amusement.

The simple act of sharing one's wine opened up an entire experience, with new friends we never would have met. They invited us into their community for some reason, but whatever it was, we're grateful and can't wait to go back and see them again.

—*Sam Fuerman*,
who works in finance in Philadelphia, was on his first trip to Paris. After the unforgettable experience, he said it will most definitely not be the last.

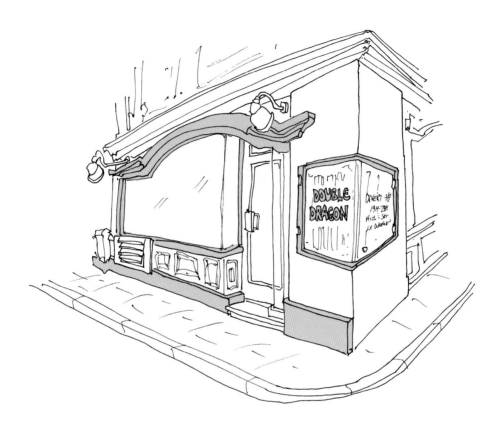

Double Dragon

52 RUE SAINT-MAUR, 11TH ARR.

Four years after opening Le Servan, the sisters Tatiana and Katia Levha, who were born in Manila and grew up in Paris with time spent in Bangkok and Hong Kong, expanded their offerings by opening Double Dragon, where they continued to mix fine French cooking with the flavors and approach of the cuisine they grew up on. It's not just Proust who knew what to do with a good food memory.

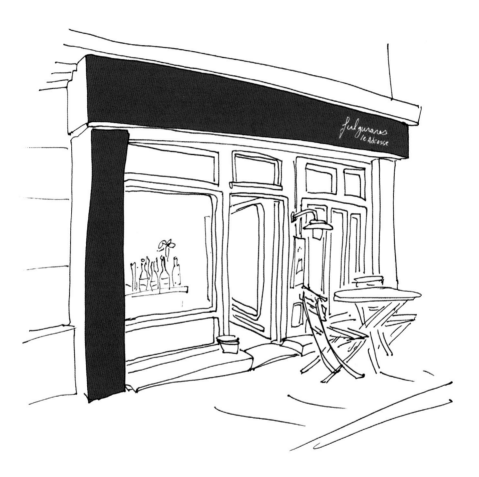

Fulgurances

10 RUE ALEXANDRE DUMAS, 11TH ARR.

Both a magazine and a place where a new young chef takes over every six months, this clean-lined dining room is great for experiencing a variety of techniques on a schedule.

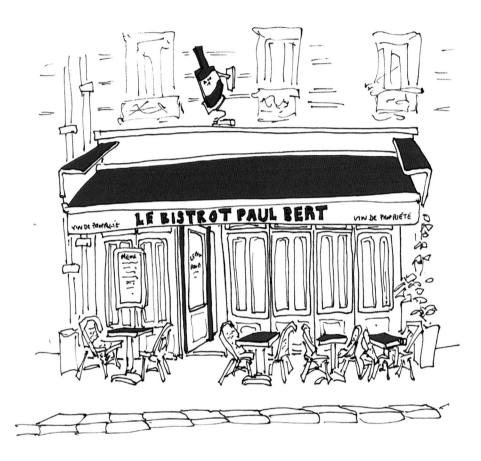

Le Bistrot Paul Bert

22 RUE PAUL BERT, 11TH ARR.

Sometimes life is full of tough choices: *baba au rhum* or *île flottante*?

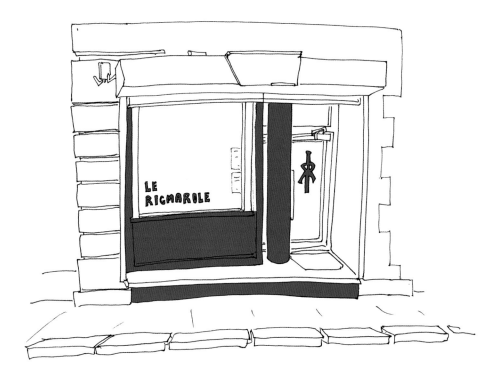

Le Rigmarole

10 RUE DU GRAND PRIEURÉ, 11TH ARR.

White Binchotan charcoal (a clean-burning Japanese variety made from hard oak) and impeccable French ingredients (which might be redundant) meet in a minimalist space to create a singular culinary experience.

Le Servan

32 RUE SAINT-MAUR, 11TH ARR.

The first foray by Tatiana Levha, who put in time at L'Arpège and L'Astrance, and her sister, Katia, was an instant success the moment it opened, in 2014, thanks to its mix of Asian-accented French cooking and stylish setting.

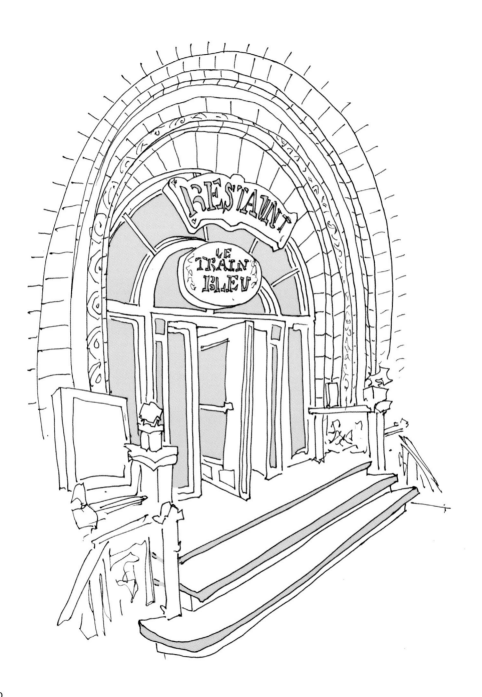

Le Train Bleu

PLACE LOUIS-ARMAND, 12TH ARR.

An interior arch at Le Train Bleu.

We had spent a week in Provence and were headed back to London with a three-day stopover in Paris. Traveling with my husband and me were our son Dan, his daughter Noelle, and her cousin Emmit. We had taken the train from Marseilles and arrived in the Gare de Lyon. Dan had made reservations at Le Train Bleu, upstairs.

We arrived feeling tired and dirty from our travels, but the staff escorted us to our white-tablecloth seating next to a window as though we were VIPs. There was room in the corner to pile our backpacks, coats, and other paraphernalia. When seated we took in our beautiful surroundings. First, the fully set table with flatware and stem-ware, the light streaming in from the many windows, then the beautiful chandeliers and the gorgeous ceiling frescoes.

As soon as we were settled, the server took our drink orders and they arrived promptly. I seldom have wine with lunch but I enjoyed the Chardonnay. For the entrée I ordered the root vegetable pot-pie, which was new to me. I enjoyed it so much that I often make something similar at home. At the end of the meal, we were escorted to the elevator, since I walk with a cane.

The original meaning of the word *restaurant* was "restore," a place for travelers to rest and restore their energy before continuing their journey. When we left, I felt I had been thoroughly pampered: relaxed, rested, and, well, restored.

—*CAROL MAHONEY*

and her husband are retired restaurant owners whose eldest son and family live in London. They visit every year with frequent side trips to France that always take them through Paris.

Mokonuts

5 RUE SAINT-BERNARD, 11TH ARR.

Sometimes things just align in a perfect way and that is what happened at Mokonuts on a beautiful, typical April in Paris day a few years ago. I'm a former Bay Stater, born and raised, who has lived in Switzerland for the past twenty years. Some friends from Nantucket, my last place of residence before moving over here, were coming to Paris for a few weeks, and, as we hadn't seen each other in a few years, we decided to meet there. Unbeknownst to me they had also invited another former Nantucketer who now lives in Bordeaux. She and I hadn't seen each other in more than twenty years and were always more acquaintances than friends, but we share the same first name and same birthdate, which I always felt was a bit serendipitous. Because of its *New York Times* review, I decided to make a reservation at Mokonuts. None of us knew the restaurant nor the area, so it was going to be a totally new adventure. I can be a creature of habit and frequent the same haunts all too often.

All four of us felt immediately at home and that we had made the right choice the second we opened the door and were greeted by Moko. When she found out that we were old friends who hadn't seen each other in years, she seemed to go out of her way to make our lunch extra special. At one point her husband, Omar, stepped out from behind the stove to come and say hello. In the twenty years I've been going to Paris, and I go at least three times a year, I don't think I've ever felt so at home or welcomed in any restaurant.

—SUSAN BEAUPRÉ-KISH,
American-born and naturalized Swiss, has lived in Europe since 1999. She has a close childhood friend who lives in Paris, so she visits three to four times a year and now knows the city so well that American friends ask her for travel ideas.

Practically half of Mokonuts's space is occupied by the kitchen.

Septime

80 RUE DE CHARONNE, 11TH ARR.

Deceptive simplicity and inspired excellence from a former graffiti artist have made this one of the hardest to secure tables in Paris today. Its tasting menu can deliver a meal of a lifetime without bankrupting future generations.

Virtus

29 RUE DE COTTE, 12TH ARR.

I was on my way to Marché d'Aligre, a place
that I've visited regularly since attending
cooking school in Paris many years ago. As
I passed the cozy yet modern restaurant,
painted an inviting shade of vivid blue, I read
the menu from the previous day. I was salivat-
ing, but I did not want to disturb the two
people in the dining room having an animated
conversation. I would later discover that they
were the chefs planning the evening menu.

I returned to the restaurant after my market
visit to make a reservation. Chiho Kanzaki,
the chef de cuisine, unlocked the door and
welcomed me graciously even though she
was busy with service preparations. She even
had a brief conversation with me about the
concept of the restaurant. It was no surprise
that Virtus was completely booked for that
evening and the following. I resigned myself
to the fact that the meal that was calling to
me would have to wait until my next visit to
Paris.

A few months later I had another opportunity to visit Paris and I made a reservation at Virtus, for my birthday, as soon as I had booked my flight. On the appointed evening, I arrived at the restaurant with my husband and a dear old friend and we were welcomed like royalty.

We were seated at a large round marble table in the center of the restaurant. It was the perfect vantage point from which to watch the culinary drama unfold. Ms. Kanzaki, who is Japanese, and pastry chef Marcelo du Giacomo, who is Argentine, have fused their respective cuisines into something magical. And as was evident from my first passing glance, they focus on the best and freshest ingredients possible.

After we settled in and toasted each other with aperitifs, a procession of unforgettable appetizers began, including a savory beetroot chiffon cake, deconstructed pizza, and declination of corn with oxalis. As we savored them, a cook came into the dining room and presented us with a handsome and fragrant canard de Challans, a highly esteemed duck that was to be our main course. As he returned to the kitchen to carve it, a server came over to present and describe the elaborate cheese platter we would soon have the opportunity to sample.

The mood was set for the beautifully composed tasting menu. A duo of inventive and satisfying fish courses preceded the magnificent duck. The intoxicating flavor and aroma faded only after our first desserts arrived. Pumpkin mousse with toasted tea ice cream and crystallized yuzu had us swooning.

Our meal ended with French sweets flavored with respective traditional teas from Argentina and Japan. Argentine mata flavored *pâtes de fruits* (fruit jellies) and Japanese matcha macarons were served on a traditional Japanese iron teapot coaster. When we were finished, the two chefs and the rest of the staff thanked us for joining them. As we walked out into the Parisian night, we looked back to offer a last grateful smile. Chiho gave us a deep parting bow.

—ROSCOE BETSILL,
a New York–based food stylist who was awarded the Grand Diplôme from La Varenne École de Cuisine in Paris many years ago, returns to the city once or twice a year to see friends, visit old haunts, and eat.

A detail from the bar at Virtus.

★ Mokonuts

5 RUE SAINT-BERNARD, 11TH ARR.

(SEE PAGE 202)

This café, one of my must-do's for every Paris trip, is utterly cute and perfectly delicious. On the fringes of the 11th arrondissement, it may seem out of the way if you're not staying in the area, but I think it's enough of a reason to venture outside your Parisian comfort zone. I go for lunch (best to make a reservation in advance—it is not open for dinner except for private parties). Simple, well-sourced ingredients shine with international influences (the owners, Omar Koreitem and Moko Hirayama, draw inspiration from everywhere they've lived: Lebanon, Japan, London, the States, and of course, France). I especially love what they do with seafood—from the perfectly seasoned shrimps to tender smoked eel. Vegetables are also stars—gorgeous endives, cresses, brassica tops gathered from nearby farms. You can bring the kids, too, which is not surprising since Moko and Omar have a couple of their own. Plus, Moko makes some of the best American-style pastries in Paris. Her cookies never disappoint.

★ Au Passage

1 BIS PASSAGE SAINT-SÉBASTIEN, 11TH ARR.

(SEE PAGE 190)

It's all small plates at this convivial neighborhood spot. Every time I go for dinner, I feel like I'm rediscovering a gem. Hidden down a narrow and dim Parisian alley, the warm glow of light is a reassuring beacon, especially if you're new to the block. The menu changes often, but you might find a fish or meat carpaccio with bitter greens to start, perhaps followed by a fatty, melting pork belly flavored with mustard, or some house-made sausages, or a braise of lentils and chicory, all accompanied by one of the natural wines or ciders on the list. Au Passage is somewhat inventive but mostly comforting, the kind of place to sit with a small group of friends and talk far into the night (they are open until 1:30 A.M.). Bonus, it's easy to make reservations online.

Le Marché Raspail Bio

BOULEVARD RASPAIL – ENTER ON LES RUES DU
CHERCHE-MIDI ET DE RENNES (BETWEEN THE STREETS
OF CHERCHE-MIDI AND RENNES) – 6TH ARR.

Whenever we rent an apartment in Paris, this is where we go for all the produce, seafood, and meat needed to cook fantastic seasonal meals. Vendors come just once a week with their prized organic offerings, and you can be sure that anything here is that much better than what you can find at the supermarché. Parisian food markets have always been a sign of the French's commitment to eating locally sourced food—and it is good to see a growing support for organic producers, especially now.

—MELISSA CLARK,
food columnist for the *New York Times* and author of *Dinner in French*.

★ Septime La Cave

3 RUE BASFROI, 11TH ARR.

Bertrand Grébaut and Théo Pourriat's tiny wine shop, Septime La Cave, which is just a few steps from their Michelin-starred Septime Restaurant, is a wildly popular watering hole for a young new generation of drinkers who gather daily to share bottles of all-natural wine. Théo handpicks small batch growers who choose to nurture the vines without pesticides and then bottle them without additives. It's a simple wine shop concept called a *cave à manger* where bottles are legally allowed to be opened and consumed on-site with snacks. On the menu? Farm-raised meats and cheeses, fresh anchovies and sardines, olives, and more. It's so popular in fact that the party spills out into the street when there isn't room left inside.

—WENDY LYN,
who has lived in Paris for more than twenty years, is a veteran restaurant consultant, private tour guide, and writer.

12

Canal Saint-Martin to Les Buttes-Chaumont

Bob's Juice Bar

15 RUE LUCIEN SAMPAIX, 10TH ARR.

At the turn of the century, Marc Grossman
(the designer Steven Alan's brother) found
himself in Paris without any healthy options,
so he opened Bob's Juice Bar in 2006, serv-
ing vegetarian fare, bagels, and, yes, juice.

Bouillon Julien

16 RUE DU FAUBOURG SAINT-DENIS, 10TH ARR.

When it came to how I wanted to celebrate my thirtieth birthday, there was no question as to where I wanted to bring in this milestone—Paris, a place that changed me. I had the privilege of living there for a few months a couple of years earlier. During that time I truly discovered parts of me I had hidden away. I learned to enjoy my own company. I learned to wander without purpose.

My return to Paris was the most spontaneous thing I've ever done. I booked the trip during the emotionally exhausting hoopla that followed getting fired, after nine years in a career I loved. As soon as I touched down in Charles de Gaulle, I felt at home again. Paris has that way about it. I reconnected with some friends and they told me I had to go to Bouillon Julien if I wanted to have a classic French meal in classic nineteenth-century ambiance.

It sounded like the perfect place to celebrate my birthday. While on the trip, I took a tour and befriended a fellow American. We connected instantly and walked most of the city together once the tour was over. While we were visiting Sainte-Chapelle, I extended an invite for him to join me at Boullion Julien the next evening. He accepted.

Once we entered the restaurant I was gobsmacked by the charm, architecture, and authenticity of the restaurant. It oozed French sophistication. Upon breaking bread, we realized that we were in similar places in our lives—him grieving a recently broken-off relationship and I, a career that I had built from the ground up. Though our troubles were different, we established a deep bond in sharing our pain but also committing to persevere and come out on the other side stronger.

Despite the presence of its vintage cash register, the classic French fare and fairy-tale surroundings at Bouillon Julien won't break the bank.

Committing to our new adventures, we decide to be brave in our culinary selections. We both tried escargot for the first time—who doesn't love anything doused in garlic and butter? I had the best duck confit I've ever had, and because we were celebrating we had not one, but two desserts. Both the caramel rice pudding and cream puffs were beyond delicious. In that moment we had a convergence of shared life experiences over a decadent meal and established a new friendship that has endured to this day.

—MOHAMMAD JAFFREY, a resident of Long Beach, California, discovered Paris for the first time in 2014 during a work assignment. He returned on the spur of the moment to celebrate his birthday.

Du Pain et des Idées

34 RUE YVES TOUDIC, 10TH ARR.

Led by the autodidactic baker Christophe Vasseur, the staff here spends some thirty-six hours to make each croissant, so savor it when you get it.

Holybelly 19

19 RUE LUCIEN SAMPAIX, 10TH ARR.

The Australians Nicolas Alary and Sarah Mouchot, who are high school sweethearts, opened this breakfast and lunch spot in 2013. Their take on the most important meal of the day was such a hit, they expanded down the street a few years later. At #5, late risers can get scrambled eggs, hash browns, bacon, and pancakes until 5 P.M.

La Fontaine de Belleville

31–33 RUE JULIETTE DODU, 10TH ARR.

Owned by a team that reinvigorated coffee roasting in Paris, this café is worth the trip for a cup of joe. There's live jazz on Saturday afternoons, too.

Le Baratin

3 RUE JOUYE-ROUVE, 20TH ARR.

The Argentine native Raquel Carena had never set foot in a kitchen before she opened this pocket-size bistro in 1987. But she quickly realized it was her home, bought a copy of Paul Bocuse's *La Cuisine du Marché*, and never looked back. "La Mère de Belleville" now has an entirely justified worldwide following for her incomparably honest cooking.

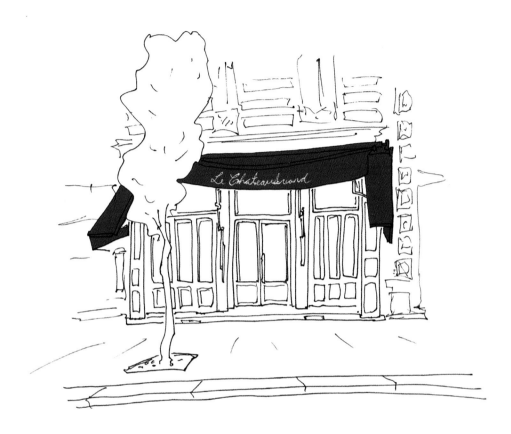

Le Chateaubriand

129 AVENUE PARMENTIER, 11TH ARR.

Inaki Aizpitarte, born in France to Basque parents, began his culinary career in Tel Aviv. In 2006 he set up shop here, turning out highly improvisational dishes with intriguing flavor combinations (cherry sorbet and capers!) at a very fair price, garnering continued international acclaim.

Le Galopin

34 RUE SAINTE-MARTHE, 10TH ARR.

In 2010, twenty-four-year-old Rommain Tischenko won the French version of the TV show *Top Chef*. A year later he and his brother, Maximme, took over this sunny spot on the Place Sainte-Marthe, a colorful vest-pocket park in Belleville, sharing their enthu-siasm for fresh ingredients and inventive cooking.

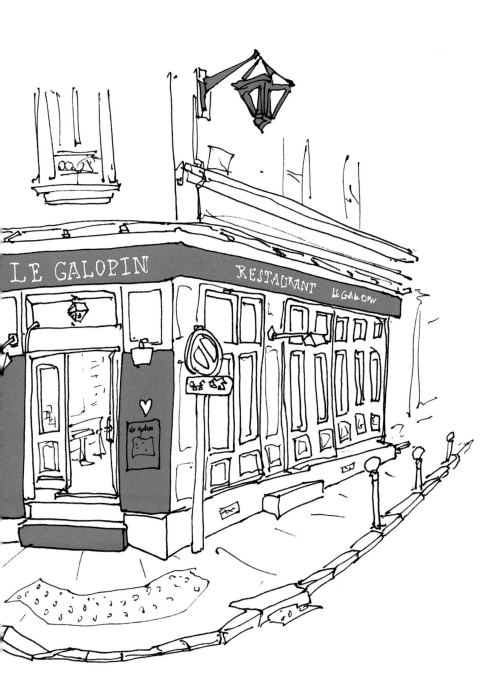

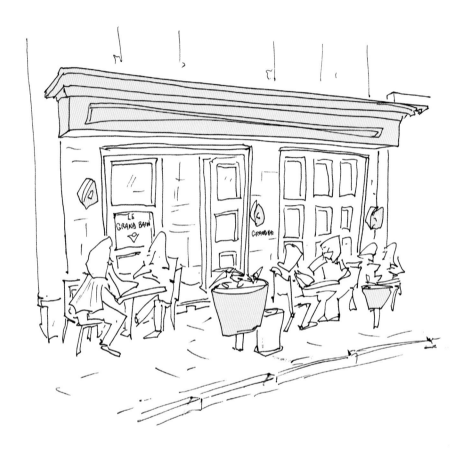

Le Grand Bain

14 RUE DENOYEZ, 20TH ARR.

The English chef Edward Delling-Williams, formerly of Au Passage, delivers veggie-heavy small plates infused with Japanese influence. The menu changes daily. The graffiti on its narrow street, less frequently.

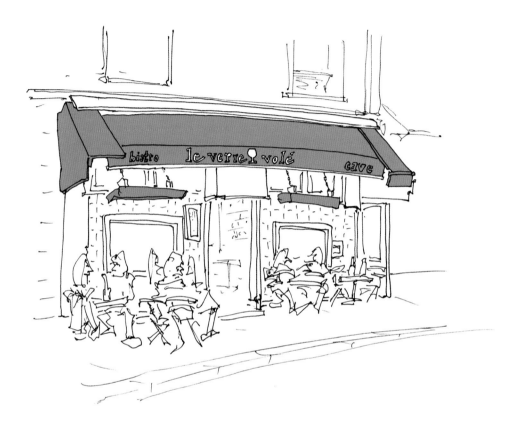

Le Verre Volé

67 RUE DE LANCRY, 10TH ARR.

The name of this *cave à manger* (a type of intimate wine shop with food that has been revolutionizing the Parisian dining scene) translates as "The Stolen Glass." The emphasis is on natural wines, but the enticing small plates and hungry crowds suggest the menu is hardly an afterthought.

Quedubon

22 RUE DU PLATEAU, 19TH ARR.

Once upon a time, Gilles Bénard brought his dream of natural wines to the foot of the Parc des Buttes-Chaumont. Quedubon has since changed hands, but the vision of a hearty, market-driven menu and matching wines remains the same.

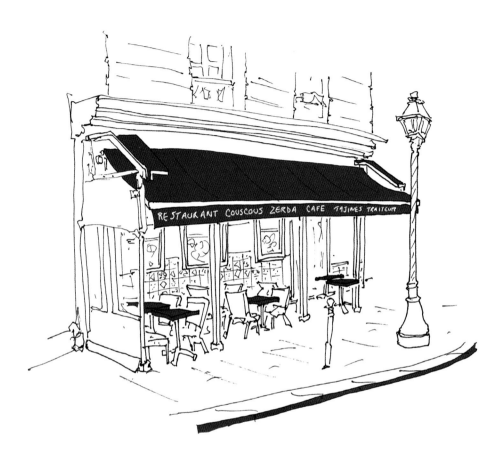

Zerda Café

15 RUE RENÉ BOULANGER, 10TH ARR.

A favorite for locals and visitors for Algerian cuisine since 1946, it is still as charming and enjoyable as the day it opened.

Montmartre Cemetery

20 AVENUE RACHEL 18TH ARR.

You need to check out the **Montmartre cemetery**. When people think of cemeteries and Paris, they immediately go for the Père Lachaise, which is overflowing with lost tourists seeking the (uninspiring) gravestone of Jim Morrison. If you want a beautiful tree-filled graveyard that's almost always totally empty, head to the foot of the Montmartre hill and get lost. You won't see any famous names, probably, but you'll escape the bustle of Paris for a while. And what's more, when you're done you've got all of Montmartre to discover.

Le Peloton Café

17 RUE DU PONT LOUIS-PHILIPPE, 4TH ARR.

Way too many tourists seek to follow the footprints of the famed faces of yesteryear. They drink coffee at the hugely overpriced cafés on the Left Bank where the waiters don't care and the coffees taste like mud. Do yourself a favor and hang out where the Hemingways of *today* would be hanging out, in expat-friendly cafés like **Le Peloton** (run by a Kiwi and Floridian). Excellent coffee, the friendliest staff in Paris, and a casual vibe.

A ★ means a suggestion is located in the current district.

Canal Cruise

VARIOUS LOCATIONS

There's something unusually fun about taking a boat along the Canal Saint-Martin. Most tourists head to the famed bateaux mouches on the river Seine, which are excellent fun, too—but once you're done with that, head to the canal. *This* cruise shows the gritty underside of the hipster neighborhoods of the 19th, 11th, and 10th arrondissements, leading you past picnicking Parisians on the canalside, then down into the underbelly of the city before spitting you out by the Seine. It's something totally different and a great way to spend an afternoon.

—OLIVER GEE
is the host of the *Earful Tower*, an award-winning podcast about Paris.

Aux Deux Amis

45 RUE OBERKAMPF, 11TH ARR.

My favorite wine bar/local haunt. The menu changes weekly (mostly vegetable and seafood-forward small plates, as well as an always exceptional large plate to share (like whole roasted sole with green peppercorn sauce). On the weekends it tends to get a bit crowded and noisy, but that's part of the fun.

Clamato

80 RUE DE CHARONNE, 11TH ARR.
(SEE PAGE 191)

Septime's seafood-only little sister. The best thing about Clamato is that on the weekends it's open nonstop from noon until midnight, so you can go in for a late Saturday lunch or early Sunday dinner, easily find a seat at the bar, and share some of the best seafood in Paris.

Restaurant Billili / Les Arlots

136 RUE DU FAUBOURG POISSONNIÈRE, 10TH ARR.

Les Arlots is my favorite classic (yet new) bistro in Paris, and for a follow-up they opened an adjoining wine bar—this only makes the experience better as you can go for a drink before or after dinner at Les Arlots or alternatively share small plates there when Les Arlots is fully booked (which is often the case).

Mokonuts

5 RUE SAINT-BERNARD, 11TH ARR.

(SEE PAGE 202)

My number-one favorite place for lunch in Paris. The food is super seasonal and fresh with both Lebanese and Japanese influences (Omar and Moko share cooking duties), and the desserts are perfect, a bit different, and never too sweet.

Racines

8 PASSAGE DES PANORAMAS, 2ND ARR.

(SEE PAGE 162)

Racines is quite possibly the most charming dining room in Paris (a perfect spot for a date), and the simple Italian food by chef Simone never disappoints (including the best vitello tonnato I've ever had).

★ Le Cadoret

1 RUE PRADIER, 19TH ARR.

I love the Cadoret mainly for its neighborhoody vibe. It serves lunch and dinner but is also open all day for a coffee on the terrace with a ham-cheese and béchamel croissant in the morning or a glass of wine at the bar with a slice of pâté in the afternoon.

Déviant

39 RUE DES PETITES ÉCURIES, 10TH ARR.

Déviant is super fun and the perfect spot for a quick drink, which always turns into a much longer affair where you end up ordering the entire menu of small bites off the mirrored walls.

Bambino

25 RUE SAINT-SÉBASTIEN, 11TH ARR.

Bambino is relatively new. The owner (Fabien) is music-obsessive and has owned a few music-oriented bars over the years in Paris. His most recent spot is beautiful (with an entire wall devoted to his record collection and speakers) and is the best place to go for after-dinner drinks (and a bite if you're still hungry).

Le Maquis

53 RUE DES CLOYS, 18TH ARR.

The kind of place everyone wishes was in their street. The lunch menu is a steal (18 euros), and at night and on Saturdays for lunch the menu is lengthier with small plates, mains, and desserts that change every day. The list is pretty lengthy, so it's a great place to go with a group for dinner as there's something for everyone. I would recommend the later service (at 9:30 P.M.) so that you don't get kicked out (they do two services a night and turnover is quick).

—CHRISTINE DOUBLET
is the head of editorial for *Le Fooding*, the very au courant restaurant guide.

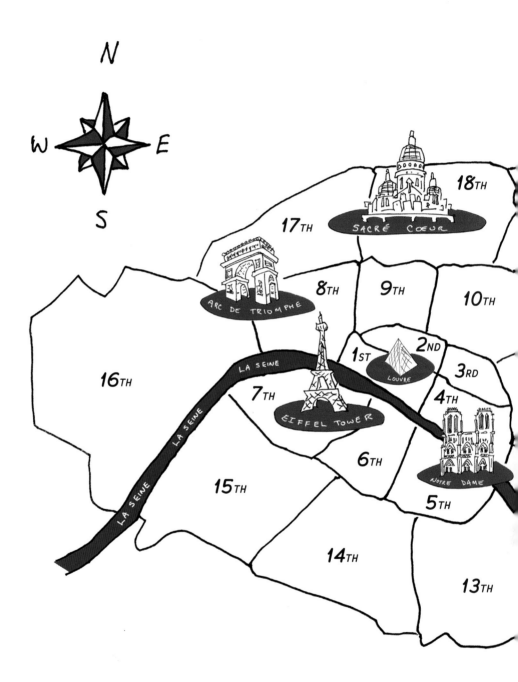

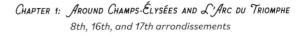

The Arrondissements, by Chapter:

INDEX

OTHER RECOMMENDATIONS

*A*CKNOWLEDGMENTS

My wife and children are the wellspring of my artist practice and I'm grateful they make it all possible. This book owes its existence to my brilliant editors Holly Dolce and Shannon Kelly. The same is true for the equally talented Meg Thompson and Cindy Uh. Thank you! Also, simply put, I was only able to do this work through the generosity of Brooklyn Community Services' leadership, especially Janelle Farris and Kristina Reintamm, as well as the support of my colleagues Kimara, Jennah, Kerry, Nahal, Janelle A., Tavia, and Joel.

Through some magic on the part of Joan Tiffany, Meredith and Pierre Charreyron and Anne and Yan Charreyron Perchet opened their houses to me, to my great relief and even greater comfort.

A special thanks goes out to everyone whose name appears in this book with a story or a set of suggestions.

Additionally, Anna Barzin, Emma Bonneville, Elizabeth Bougerol, Jimmy Bradley, Patty Diez, Patrick Ibanez, Lynn Juang, Rose Kernochan, Amanda Kludt, Elena Liao, Kelly Murphy, Lou Murrin-Honoré, Jules Pearson, Claire Pelofi, Elana Rover, Emily Rubin, Marni Sabin, and Ayesha Siddiqui shared their favorite places with me. Carla Ciminera and John Wyles and Lindsey Tramuta their company and Courtney Traub her expertise with French.

The continued wise counsel of Paul Halligan, Erik Gardner, Mike Gracia, John Wyka, William Stenhouse, Dušan Sekulovic, and Guy Wiggins has been invaluable. Betsy Andrews, Katie Baldwin, Sharron Diedrichs, Perri Dorset, Liz Graves, Sohrab Habibion, Doug Hamilton Milda De Voe, Blake Eskin, Paul Greenberg, Tina Holt, Zoë Pagnamenta, and Aja Simpson have been more than a great help, too. Olivier Imbert and Smaranda Tolosano as well. I wouldn't be where I am without the support of my mother, as well as my sisters and brothers and my father-in-law.

Thank you, too, to the team at ABRAMS, including Darilyn Carnes, Gabby Fisher, Jessica Focht, Jenice Kim, Rachael Marks, Margaret Moore, Mike Richards, and Diane Shaw. The amazing folks at Skink Ink, especially Philip, Vera, Brandon, Casey, and everyone else there, really made this project possible. And above all, to everyone who has shared a story, visited my website, or ever ordered a print—thank you.

Editor: Shannon Kelly
Designer: Jenice Kim
Production Manager: Rachael Marks

Library of Congress Control Number: 2020944920
ISBN: 978-1-4197-4778-6
eISBN: 978-1-64700-295-4

Printed and bound in China
10 9 8 7 6 5 4 3 2

Abrams Image books are available at special discounts when purchased in
quantity for premiums and promotions as well as fundraising or educational use.
Special editions can also be created to specification. For details, contact
specialsales@abramsbooks.com or the address below.

Abrams Image® is a registered trademark of Harry N. Abrams, Inc.

ABRAMS The Art of Books
195 Broadway, New York, NY 10007
abramsbooks.com